up

700026256944

D0343947

Celtic

Inspirations
For Machine
Embroiderers

Acknowledgements

Many thanks to all our colleagues for lending us work for the book. Thanks also to Clive Grey for all his work on the historical aspects, David Nicholls for the use of his drawing methods and Michael Wicks for the excellent photography. Steve Bevis of Salisbury Sewing Machines keeps us stitching and we thank him for that.

First published 2002

ISBN 0 7134 8750 X

A CIP catalogue record for this book is available from the British Library.

Book typeset in Frutiger
Printed in Spain by Just Colour Graphic, S.L.

for the publishers

B T Batsford
64 Brewery Road
London N7 9NT
England

www.batsford.com

A member of **Chrysalis** Books plc

Celtic
Inspirations For Machine Embroiderers

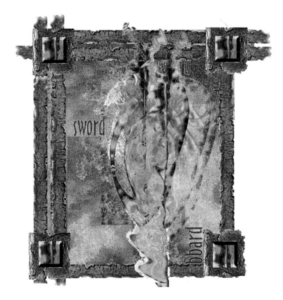

Valerie Campbell-Harding & Maggie Grey

B T Batsford Ltd • London

Figure 1 A computer design for a book cover, based on a Celtic book shrine. Drawings of zoomorphic creatures were scanned and manipulated to fit the inset panels. A special effect gives the appearance of enamelling.

Contents

Introduction

The Celtic people emerged into history in the Danube valley of Central Europe. At first, they lived quietly as farmers. Then they began to work with iron. The Hittites of Asia Minor (modern Turkey) worked iron, but it is not known by what route or over what period of time the skills passed to the Celts.

Having gained this knowledge, the Celts quickly developed iron for military purposes. Territorial expansion took them across most of Europe and beyond. They spread into Spain and merged with the indigenous inhabitants to form the Celtiberians. At this time also, they arrived in the British Isles, eventually spreading out over most of the land area. However, the Picts in the north of Scotland survived, apparently as a separate culture, until much later. In 390 BC, the Celts overran the whole of Italy and sacked Rome. It is a matter of history that the Romans recovered and were eventually to bring about the demise of the Celtic civilization in its military form. In the meantime, the Celts set up the kingdom of Galatia in Asia Minor which, as it happens, bordered regions of the iron-working Hittite kingdoms, which by then were extinct.

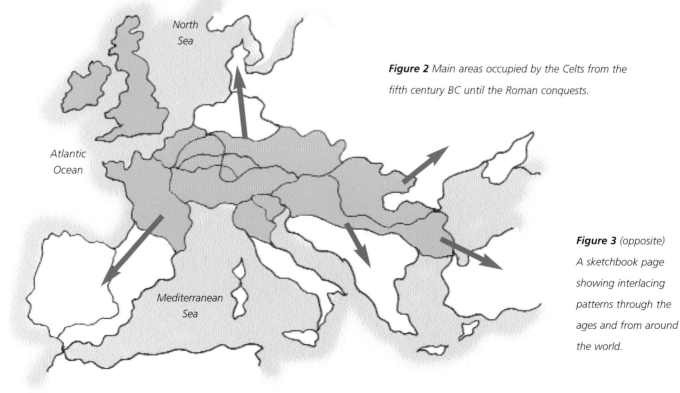

North Sea

Atlantic Ocean

Mediterranean Sea

Figure 2 *Main areas occupied by the Celts from the fifth century BC until the Roman conquests.*

Figure 3 *(opposite) A sketchbook page showing interlacing patterns through the ages and from around the world.*

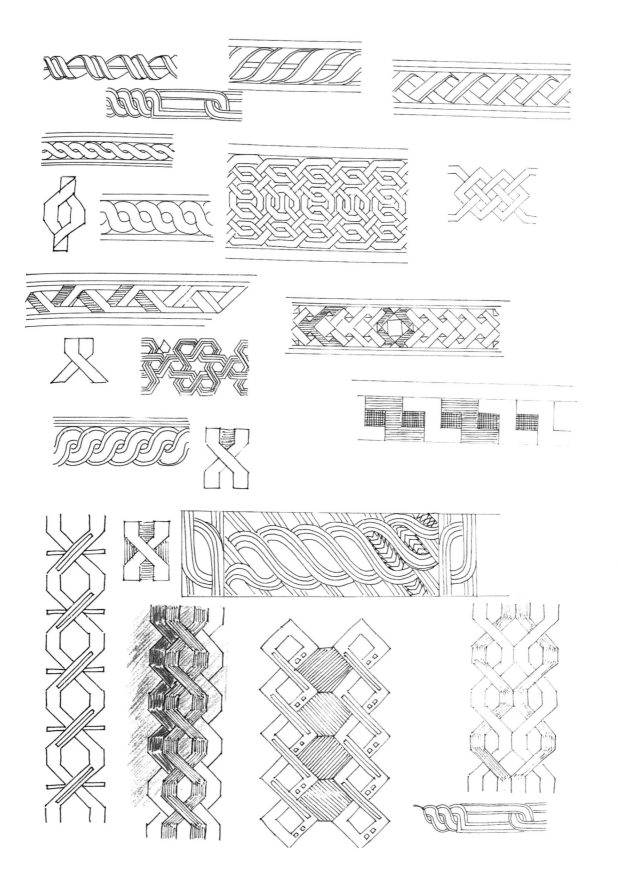

Celtic artefacts tend to be identified as being from two distinct periods, each of them named after the location where the earliest discoveries were made: Hallstatt, Austria (700–500 BC), and La Tene, Switzerland (500 BC onwards). The early artefacts tended to be objects of war (curvilinear shield bosses were common) but the helmets that survive were highly decorated and used for ceremonial purposes. Later artefacts, especially from the later La Tene culture, were unsurpassed in their range and delicacy. By now, the inspiration of other civilizations, particularly those of the Greeks and Romans, influenced Celtic work, so that it was no longer definable as being peculiarly Celtic.

That was not the end of the story. Although the Romans overcame the Celts throughout their homelands in Western Europe, Ireland in particular remained unconquered by arms. However, it was conquered by another force – that of the Christian Church. Metal-making skills had continued to develop and these were refined by the new literacy introduced by the missionaries. The combination of these skills was to result in their magnificent illuminated manuscripts.

So we can trace the build-up of Celtic designs from the simple spirals of the war artefacts through knots, plaits, spirals and meanders, to the glories of the metalwork designs and the manuscripts such as the Book of Kells and the Lindisfarne Gospels.

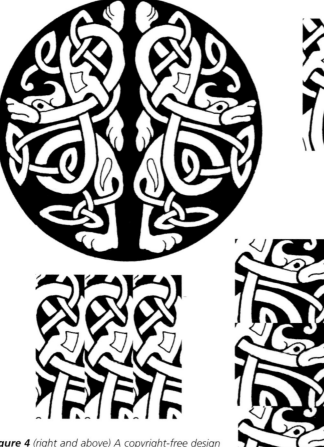

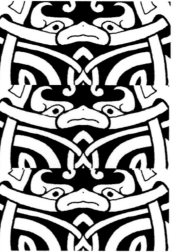

***Figure 4** (right and above) A copyright-free design taken from a Dover CD-ROM. Parts were isolated, repeated and coloured to make further patterns.*

It is interesting to note that the Celts were not the only people to use interlacings, plaits and meanders. Figure 3 shows some of these patterns.

There is a wealth of information available in the form of books, although care must be taken not to infringe copyright. The Dover series of books is copyright-free, and also includes a range of designs on CD-ROM. You will find a list of resources at the back of this book (pages 124–25). Stencils and rubber stamps are extensively available, but we will show you how to make your own. Such is the appeal of Celtic designs that you can find such items as tiles and teapot stands, many of which are suitable for rubbings and can be used in your designs. Clipart and fonts for word processors are available, even if you only have very basic computer facilities. Enter the word 'Celtic' into an Internet search engine and you will be overwhelmed with information and suggested sites. Again, we list some of the best of these sites in the Resources section (pages 124–25).

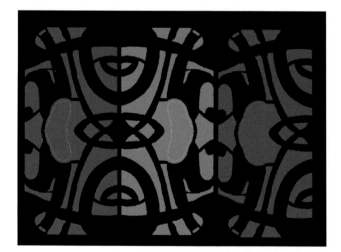

Figure 5 *The bird design was altered to look like a string block, a stencil and a printing block (shown in the lower images).*

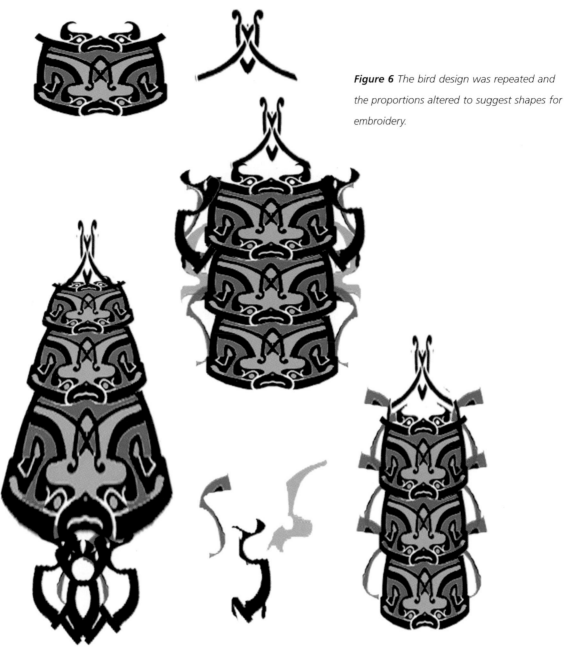

Figure 6 The bird design was repeated and the proportions altered to suggest shapes for embroidery.

Do visit museums, many of which have examples of Celtic pieces. The British Museum in London and the National Museum of Ireland in Dublin, in particular, will fill you with wonder and inspiration. Even if you don't rate your drawing skills very highly, a lightning sketch, with written notes, can be very informative, so take your sketchbook and draw some of the exhibits. Many museums allow photographs so long as you don't use flash. Digital cameras can be a great help here, with the advantage that you can bring the photos into your computer for design. Moreover, a visit to a site can be documented with photos, sketches and notes.

This book gives detailed information on how to draw knots and plaits using a simple method. It continues through design methods, starting simply and building up to more complex designs, some using the computer or photocopier, many showing new ways for tried and tested processes. You can then go on to stitch armed with lots of new ideas, as well as new slants on old favourites.

Figure 7 A distorted knot design was used to make a
pressprint block, which was printed on both paper and
black fabric. A stitched sample was then prepared using
quilting techniques.

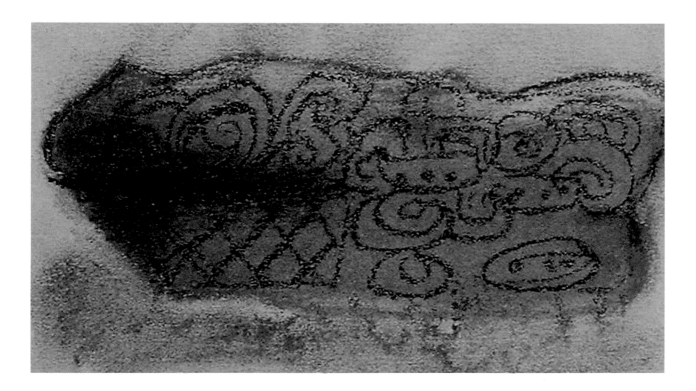

The final chapter, on putting together finished pieces, aims to demystify this process and – should it all go wrong – shows how to redeem an uninteresting piece of work.

We are indebted to David Nicholls for allowing us to use his method of plotting knots and plaits. The drawings underpin all the design methods, which in turn lead on to finished stitched pieces.

Do enjoy exploring your chosen source using the drawing and design methods shown here. It can be difficult taking an often complex source such as Celtic design where the objects or manuscript pages are already quite wonderful. How do you improve on perfection? The answer is not to copy a design exactly when translating it to a textile, but to take certain aspects of it and, through experiments and stitch samples, make it your own. The methods shown here can, of course, be used for any other design source.

Figure 8 *(above) Very rough sketch hastily drawn while visiting New Grange, County Meath, Ireland. Notes help to jog the memory.*

Figure 9 *(below) Small sketch isolating design motif from a sketchbook drawing.*

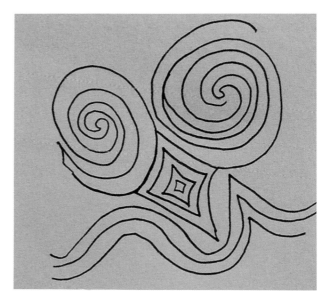

Knots

C eltic knots, which are based on simple
weaving, are found carved into stone, drawn
in illuminated manuscripts, engraved into the
body of metalwork and also used to form a raised
filigree pattern in metal.

Knots have long stood as symbols of unity and have
been given as love tokens, often in the form of
jewellery, through the ages. Many civilizations have
made use of the symbolism of the knot, from the
Greeks, who used the reef knot on jewellery, to the
Ancient Egyptians, who also used the reef knot to
symbolize the uniting of upper and lower Egypt.

Religions have made use of the knot to
represent the closeness of God and man,
eternal life being a particular instance in the Christian
illustrated gospels. In Buddhism, the endless knot is
one of the auspicious signs.

We can see, therefore, that knots form part of a
worldwide heritage of design language, and we shall
look at the knots used in Celtic design in particular.

The following is a method, pioneered by
calligrapher and stone carver David Nicholls, of
drawing simple knot patterns to translate into design
and then to stitch.

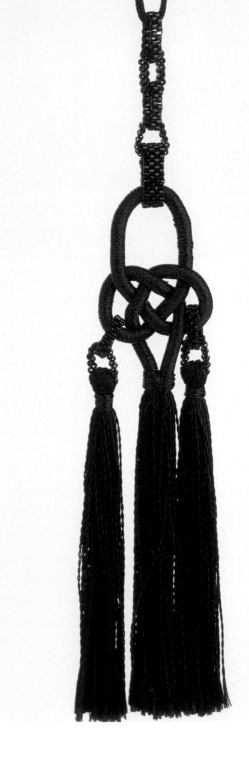

Figure 10 *A tassel made of handwrapped yarns tied into a knot,
and decorated with beads.*

King Solomon's knot

When working through these instructions, refer to the diagram continually – remember, a picture paints a thousand words.

A Measure and draw nine small circles to form a square. Start with circles about 2.5cm (1in) away from each other. Join the circles by drawing faint lines. This will result in four squares within the overall, larger square.

B Add another small circle in the centre of each of the four squares. Again drawing faint dotted lines, connect any four circles, two original and two added, to make a complete diamond.

C With firm pencil marks, draw parallel lines on two opposite sides of the diamond, keeping the lines on the inside of the circles.

D Again with firm pencil marks, draw two more parallel lines working out from, and at right angles to, the original ones. In order to achieve the weaving effect, it is essential to keep inside the circles.

E Draw two more parallel lines (remember to keep inside the circles) working out from and at right angles to the pair just completed, keeping all the lines within the original square.

F Draw in the four corners, using a neat curve where necessary. Finally, draw in the little loops around the faint circles described above, going three-quarters of the way around these circles until dissected by a straight line. Make sure that your drawing suggests that the ovals are interlaced.

G The final diagram shows the finished knot.

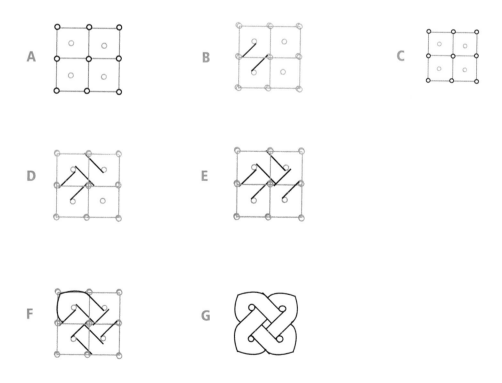

Josephine knot

When working through these instructions, refer to the diagram continually. This knot is often found in crochet and rug making.

A Draw a grid of circles as described under King Solomon's knot (page 15), note (a), but this time use four across and three down. Add faint lines to join the circles, forming a rectangle. As before, draw a small circle in the centre of each of the six squares formed. As for King Solomon's knot, note (b), connect any four lines to make a diamond anywhere within the rectangle.

B With firm pencil marks, draw parallel lines on two sides of the diamond, keeping the lines on the inside of the circle.

C Again with firm pencil marks, draw two more parallel lines working out from and at right angles to the original ones, again keeping inside the circles. In order to achieve the weaving effect, it is essential to keep inside the circles.

D Continue to add pairs of lines (remember to keep inside the circles) working out from and at right angles to the pair just completed, keeping all the lines within the original rectangle.

E Draw in the four corners, using a neat curve where necessary (but remembering to keep within the original rectangle). Draw in the centre curves.

F Finally, draw in the little loops around the faint circles described above, being careful to follow the direction of the weave.

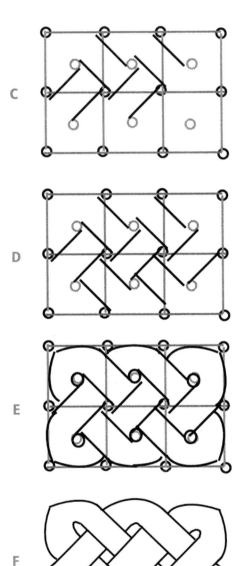

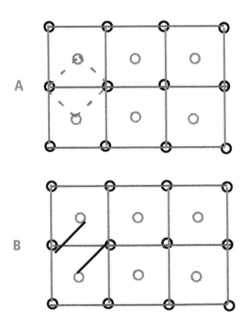

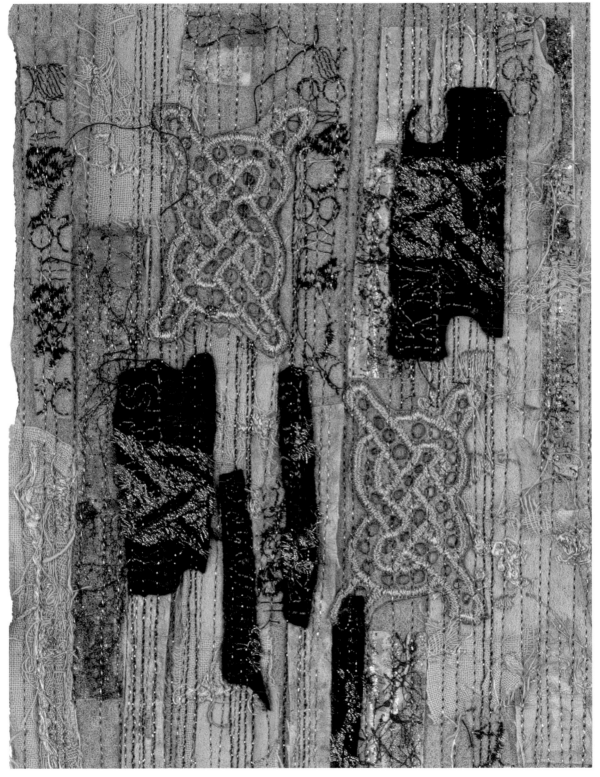

Figure 11 *Coffee-dyed fabrics bonded to coffee-dyed felt, with some wisps of stitching on vanishing muslin and scraps of stitching applied to it. Lines of straight stitching secured all the pieces. The two knots were scanned and stitched, cut out, then holes were burnt using a soldering iron, and secured with free running.*

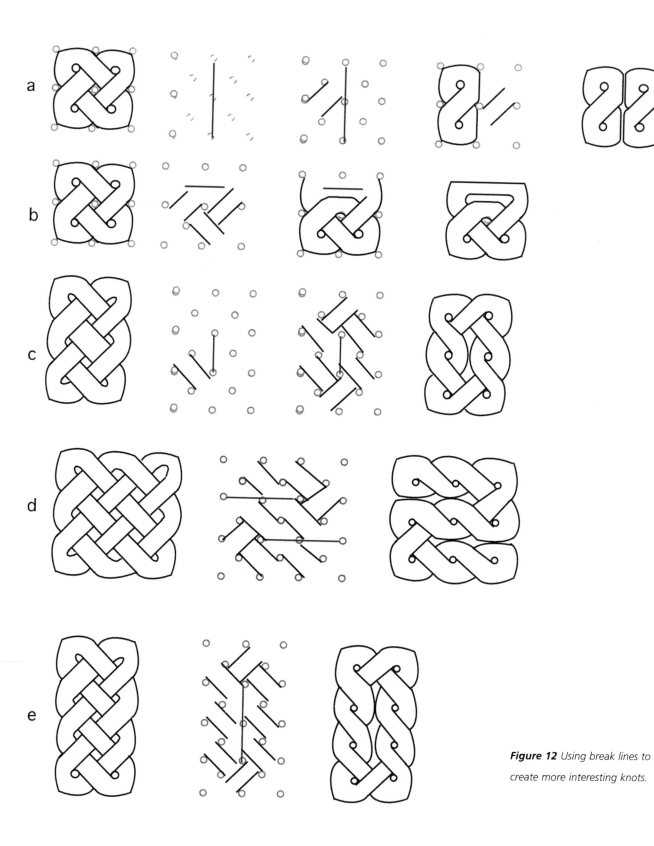

Figure 12 *Using break lines to
create more interesting knots.*

Break lines

The Celts had the imagination to insert 'break lines' into their interlacing patterns, thus forcing the bands or straps to change direction. It is this characteristic that makes Celtic patterns so distinctive, whereas similar patterns from other sources just go on unbroken or change direction at the end.

Rules for break lines:

■ Break lines can be inserted horizontally or vertically but never diagonally.

■ They can start and finish anywhere but must join circles.

■ There can be any number of break lines.

■ A pattern cannot cross a break line.

Draw a grid as for the King Solomon's knot (page 15).

A Drop a line down the centre of the box, from top to bottom. Imagine the diamond as before and draw the first pair of parallel lines.

B The pattern cannot cross the break line, so take the outside curve up the break line, across the top and down the outer edge, finishing with a very short curve to meet the centre diagonal line.

■ Continue by drawing a 'hook' around the centre circle. Finish the other end to match.

■ Look at your drawing and note how the break line has forced the pattern to change.

■ Now complete the other side, noting that the parallel lines can either match or mirror the original lines.

In Figure 12 we have shown one example for each shape of knot, and suggested break lines for you to complete.

■ Photocopy this page.

■ Be careful when drawing the parallel lines, as some are not drawn in the places where you expect them to be.

■ Figure 13 shows the effect of colour and the build-up of a design based on knots and break lines.

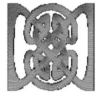
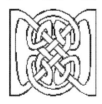

Figure 13 Parts of the design were selected, enlarged and the background filled with black to give more punch.

19

Shading

When you are drawing more complicated knots, it is easier to follow the weaving patterns if some of the lines are shaded. Figure 14 shows how the woven bands work by separating the straps with shading and dotted lines. Note how this changes the look of the knot – particularly when three or more shapes are interwoven. The Celts often used dots to decorate their lines, and in your work, these could be translated into French knots, eyelets or holes burnt with a soldering iron.

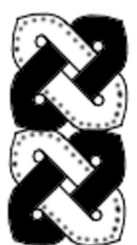

Figure 14 *Knots can be shaded to look more three-dimensional, parts filled in with another colour to make the pattern more obvious, and decorated with dots.*

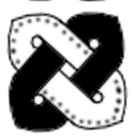

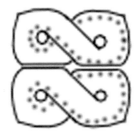

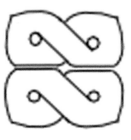

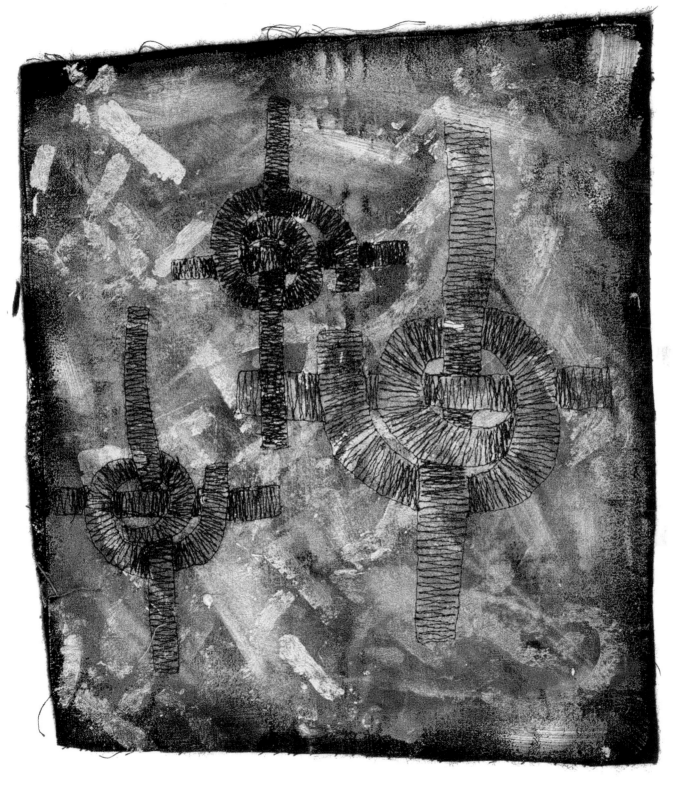

Figure 15 *Xpandaprint (Puff Paint) was thinned and brushed onto a fabric. Thicker Xpandaprint was applied through a stencil. The stitched knots, using free-running and whip stitch, show deeper shading to give a woven effect.*

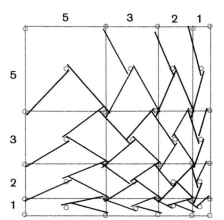

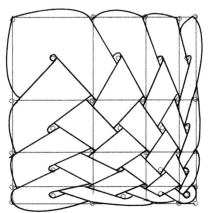

Figure 16 (left and right) A knot distorted using a grid.

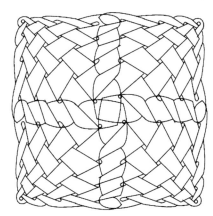

Figure 17 The same four knots were overlapped at the centre to give a different design.

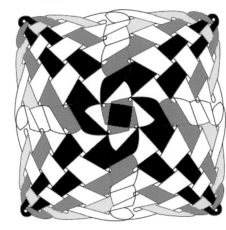

Figure 18 Some of the strips were filled in to clarify the pattern.

Figure 19 (below) A knot distorted using a different grid.

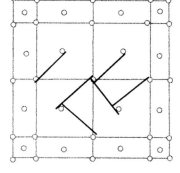

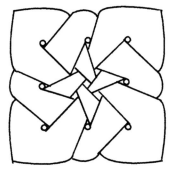

Figure 20 (below) Another distorted knot using a different grid.

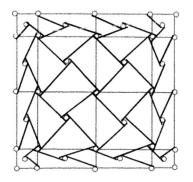

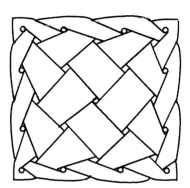

Further distortions

You may wish to distort a design just for fun, or to fit into a particular shape you wish to use. The figures opposite show how to use the grid method. For a more free effect, try the following.

Distortion using tights

Try the following option using tights (pantyhose) or stockings. Pale colours are best, but darker ones can be bleached using a 50 per cent bleach solution. Leave the tights to soak for a while and then boil them to really reduce the colour. Rinse well and then wash thoroughly.

1 Draw out your design clearly on paper. Tape or pin this to a pinboard and lay over it a cut-out section from the tights. Pin this over the design, not stretching it too much but keeping a sufficient tension to allow you to draw around the lines of the design with a soft felt pen. This is easier if you draw in a series of dots, rather than lines (which tend to pull the fabric).

2 Remove the design from the board and re-pin the fabric, this time pulling and stretching it so that the design is distorted into the shape that you want. Place tracing paper over the top and draw the distorted pattern from the tights.

3 Repeat the exercise to make a series of patterns from the same motif. You can use these with stencils or block prints, as described later in this chapter.

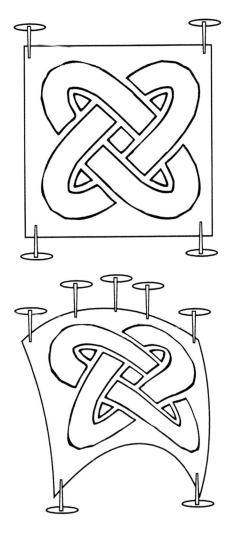

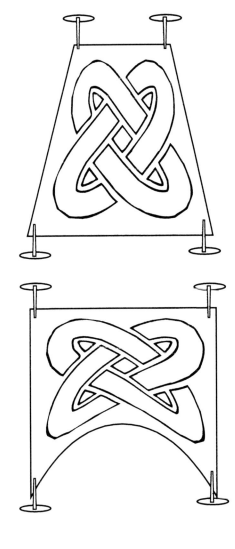

Figure 21

A knot distorted using the tights method.

Distortion using a computer

This can be done in a paint or draw program.

1 Scan in a drawing or pattern, or draw from scratch on the computer.

2 Distort the image using commands such as Skew or Distort. Different programs have different ways of doing this – one has envelopes that curve or bend the patterns. Paint programs often have Wave, Bend or Ripple filters in the Special Effects menu. When using these filters, do try changing the settings, as some unexpected results can be obtained by doing this. Liquefy is another effect: it allows you to push and pull the design in different directions.

These distorted motifs can be carried through to stitch by making them into stencils, or you can use other design methods, as described later in the book.

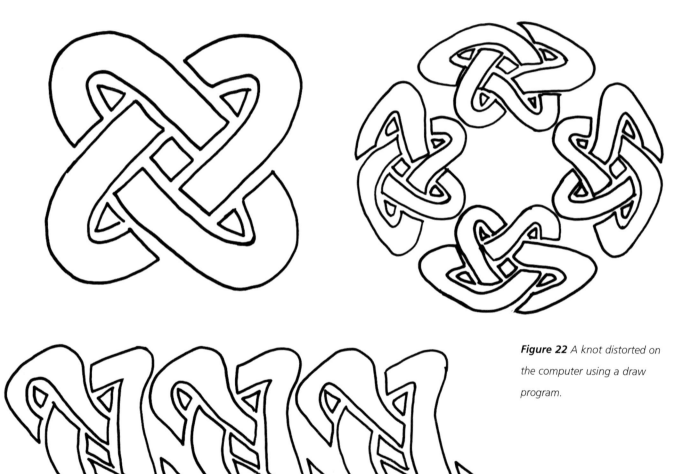

Figure 22 *A knot distorted on the computer using a draw program.*

Figure 23 *A distorted knot has been copied onto water-soluble paper. Parts have been resisted (far left) and, after light stitching and washing away the remaining paper, the piece has been painted and embossing powder used to highlight areas (left).*

Figure 24 *The distorted knot on water-soluble paper, shown in the previous figure, has been used as a border in this piece. The body of the sample is made from stitched acrylic felt, zapped with a heat gun. Cable-stitched knots, using water-soluble fabric, were applied on top.*

Knots

Design development

Further designs can be developed by tracing one of
your knot drawings and then using the tracing to
extend the original knot by mirroring (turning the
tracing over to reverse the design), flipping and
rotating it. Try taking different parts of the knot as your
starting point. Figure 26 shows lots of possibilities.

Figure 25 (right) *Tassels using stitched and wired knots, laid
back to back and stuffed. Paper beads, knotted zigzag cords
and tiny beads add further decoration.*

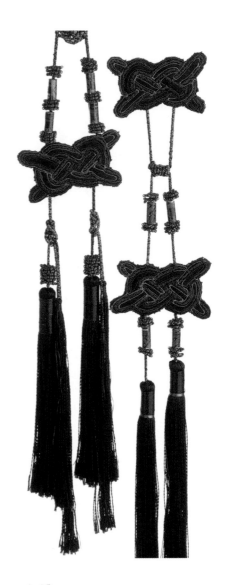

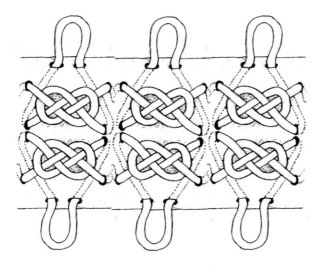

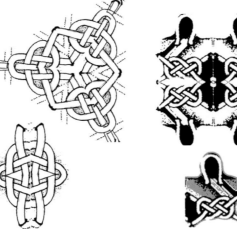

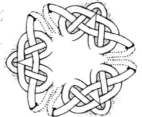

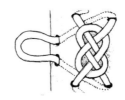

Figure 26 *Drawings of
a looped knot,
repeated to show
some of the patterns
that can be made.*

Alternative knots

The methods given for drawing Celtic knots can be used with other knots too. The image in figure 27 shows how simple knots in cord can be observed and drawn using the grids and circles techniques shown right. Figure 28 shows a quick drawing method that does not use curves. This is very easy to do in a draw program on the computer. There are ideas here for taking this approach further.

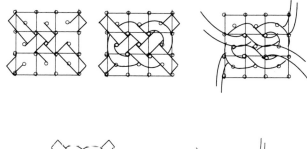

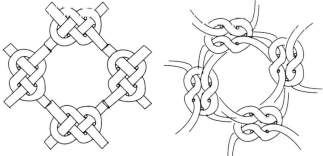

Figure 27 (right) *A Carrick bend and a reef knot repeated to make circular patterns.*

Figure 28 (below) *A quick method of drawing knots on the computer using straight lines, which are easier to do than curves.*

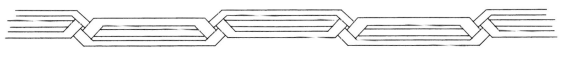

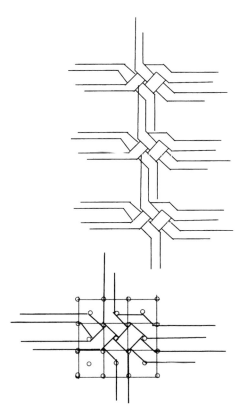

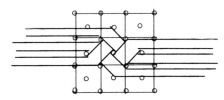

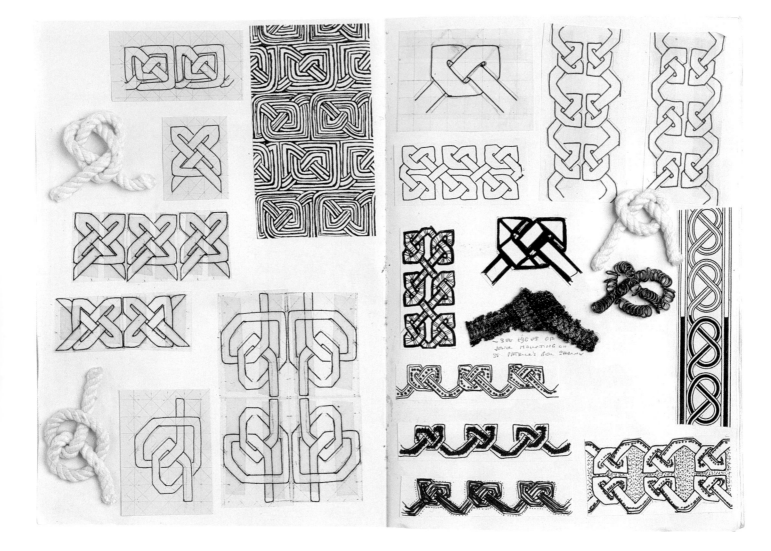

Figure 29 *Knots tied in a piece of cord were drawn using the method given in this book. The drawings were repeated and mirrored to make patterns.*

Stencils

You can develop designs from your knot drawings by
making stencils. Special stencil film is available (see
Suppliers on page 126) and you can cut into the film
using a craft knife, soldering iron or electric stencil
cutter. When making stencils from the knot drawings,
consider carefully the areas to be cut away. You will
need to build in 'bridges' as you design, to ensure that
the area with the stencil holes is not cut completely
free (figure 30). Obviously, cutting out the entire
central area would result in a large hole. When bridges
are added at the points where the straps interweave,
the result is a series of shapes that can be cut out,
leaving the white areas intact to hold the stencil
together. Figure 31 shows the process and the resulting
stencil. Prepare the designs and cut them out carefully
using your chosen cutting method. Used carefully, a
library of stencils can be built up and will prove useful
for lots of future projects.

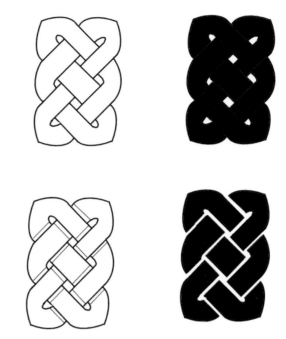

Figure 30 (above) How to change a design into a stencil, leaving
bridges to connect the holes so the whole design does not fall out.

Figure 31 (below) A stencil using a knot in figure 29, printed on
fabric and stitched using narrow satin stitch.

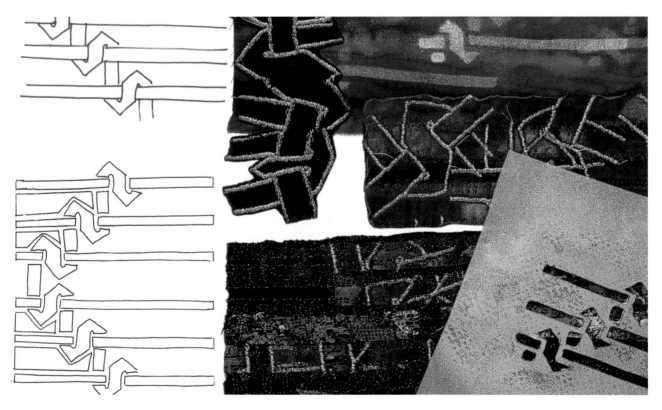

Before you use the stencil, make some background papers using Brusho powders, poster paints or inks. Interesting effects can be achieved on background papers by using crumpled clingfilm (Saran Wrap) over painted surfaces while the paint or ink is wet. For a really exciting piece, try placing these in a freezer (well away from food). The crystals that form make wonderful patterns. Allow to dry, and remove the clingfilm (Saran Wrap). Using your stencil over the top of these papers should give some good results. You could also try using resist methods – wax, candle, etc. – on the paper before painting. These could be translated into fabric using batik wax or similar. Consider colour and contrast: if the backing papers are dark, use gold paint with the stencil. Lighter backgrounds will look good with dark paint. Acrylic paints are good for stencilling. They can be applied through the stencil by dabbing with a sponge or painting with a brush, or by using a special stencil brush with an up-and-down brush action. Be careful not to smudge recent stencils when making repeats – allow them to dry (very fast with acrylics) before moving the stencil across the paper.

Removing colour using the stencil can give exciting results. Ink can be removed by dabbing bleach through the stencil, and Brusho powder can also be used with bleach. You may need to experiment with the bleaching technique, as strong bleaches should be diluted with a little water. Ink a sheet of cartridge paper and make a sampler to get the strength right. For an interesting effect, try using silk paints (which do not react to bleach) on paper as a background. Just dab on with a sponge here and there – there is no need to cover the entire page. When these are dry, paint over with ink (Quink or a similar medium bleaches well). Now use your stencil and dab some bleach through with a sponge: not too much as you are after a gentle effect. Note how the bleach works through the ink to reveal the colour below.

A similar effect can be achieved on fabric using a special discharge paste. It is wise to buy the treated fabrics that are sold especially for use with this product. Follow the directions carefully. You can either bleach out the original colour (usually black) and then add different colours afterwards, or do it at the same time as the discharge takes effect. Use the stencil in the same way as you did on the paper version.

***Figure 32** A drawing of a knot was made into a stencil and a variety of paints were used to make patterns on the paper. Some of the designs were further embellished using a gold pen. Top right shows discharged fabric; below left and right show a design that has been bleached back to reveal silk paints below.*

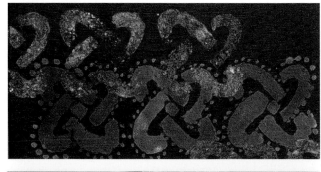

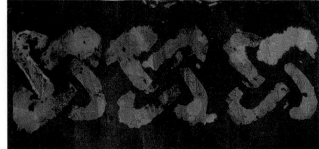

Figure 33 *A pressure stencil was made using an interlaced design. A nappy (diaper) liner coated in Markal was ironed over the top, then some hand stitching was added.*

Pressure stencils

Using a smooth plastic stencil on paper or fabric, an exciting result can be achieved by laying the stencil over painted fabric and allowing it to dry naturally. Use silk paints or very fluid fabric paints and try the following.

- Damp some white cotton, polycotton or silk and place on a piece of glass or very smooth thick plastic. If using paper, use a heavy cartridge or watercolour paper and only damp lightly.
- Shake or flick some silk paints, two or three colours, directly onto the fabric.
- Place a plastic stencil over the fabric and leave to dry.

Very strange things happen to the colours – the darker tones are drawn to the open areas of the stencil. It is all rather unpredictable but can be very exciting.

Dispersing pattern with pressure

Work exactly as before but, having placed the stencil over the painted fabric, the next step is to place weights (bottles of bleach, paint jars, etc.) in certain areas. The pattern will not show in these areas and the colours will blend and migrate.

Add texture with a nappy (diaper) liner (see page 69) and stitch using straight lines or a narrow automatic pattern. The quilting stitch that is available on some machines is ideal. This utilizes monofilament thread on top and pulls the bobbin colour to the surface to resemble hand stitching. The design could be emphasized using machine quilting.

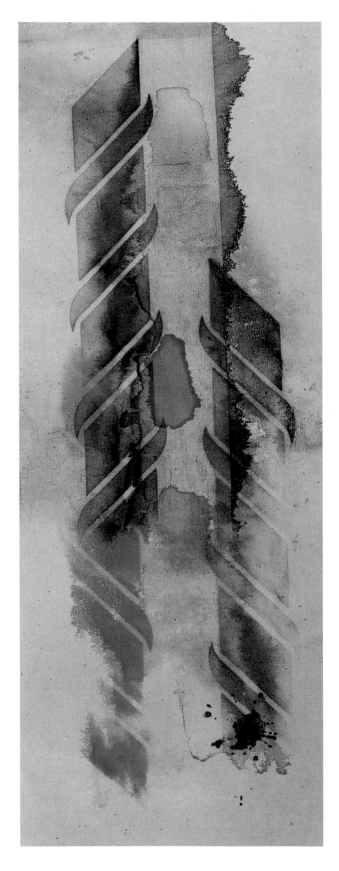

Figure 34 *Pressure stencil done in two stages, allowing the fabric to dry between each.*

Into stitch

The stencils can be used to apply colour and shape to the background fabric in just the same way as they were used on paper. Use the designs and follow the colour schemes in them to prepare stencilled fabric ready for stitch. The clingfilm (Saran Wrap) method could be used together with fabric transfer paints and ironed onto synthetic fabric when dry. This effect can be used as backgrounds for the stencils. Other backgrounds could be silk-painted or discharge-dyed. Use the stencil as before. When the paint has dried, think about how to stitch.

The stencilled areas could be highlighted by hand or machine stitching. You could also blend the shape into the background by using lines of straight stitch over the top of the stencilled fabric. This will integrate the stencil with the background and motifs, and then further stitching could be applied on top.

Alternatively, stencil directly onto painted Vilene, handmade or commercial silk paper or felt. Cut out the stencil shape and either apply to a stitched background, using more stitching, or use as padding under a sheer fabric and outline the shape as for shadow quilting. Or the stencilled shapes could be densely stitched with machine embroidery before cutting them out and applying them to another background. A sewing machine or computer scanner could also be used to transfer the design to sewing-machine software.

Figure 35 *Coloured silk 'paper' was stencilled in gold using a knot design. A nappy (diaper) liner was laid on top, stitched and melted away with a heat gun.*

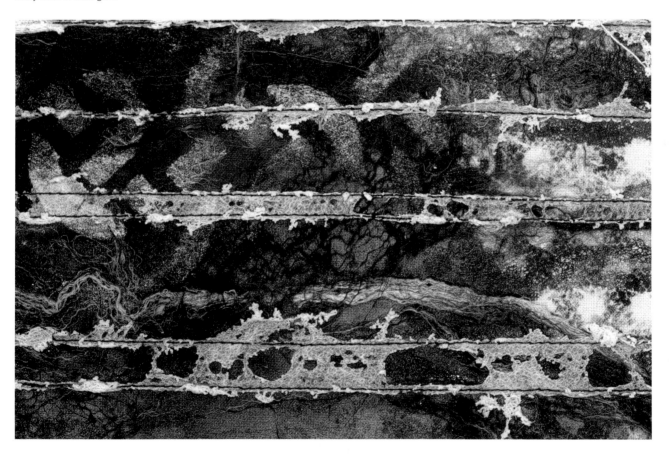

Quilters' freezer paper

This is a waxy paper that can be ironed onto fabric to hold it in place while you stencil. Available from cookshops in the USA or from quilters' suppliers elsewhere, you may be able to obtain a free supply by investigating the wrappings that come with your printer or photocopy paper. Draw, trace or stencil your design onto the paper and cut it out carefully with scissors or a craft knife. Iron onto your fabric, keeping the waxy side of the paper next to the fabric. Use a medium iron, and don't iron for too long or it you will find it will be difficult to remove. This method works best with a smooth fabric. Freezer paper can be removed and ironed onto new fabric several times before losing its adhesion.

This method is particularly good when used with techniques such as marbling, as the stencil will stay in place when dipped into the marbling tray. Thin spirit-based metallic paints (Blackfriars in the UK) that can be purchased from hardware stores give good results and are very easy to use. Always use them in a well-ventilated room. Shake well and pour a very small amount into a tray of cold water – cat litter trays are excellent and cheap. About a 5 ml spoonful (teaspoon) should suffice, as it will spread across the surface. Now use a kebab stick, or similar, to twirl into shapes. Iron the stencil onto the fabric and place it on the water by drawing it over the tray from the far side and gently allowing it to drop into the water. Remove to a piece of newspaper and allow to dry. It should need no setting and can be washed if care is taken.

Keep the pieces that you cut out. Use a simple, easily cut design. These pieces can also be used as a resist, giving quite different results. Iron onto the fabric in the same way.

Figure 36 *Freezer paper was used to make a stencil from figure 18. This stencil was ironed onto fabric and marbled with Blackfriars paint. The result can be seen on black cotton (right).*

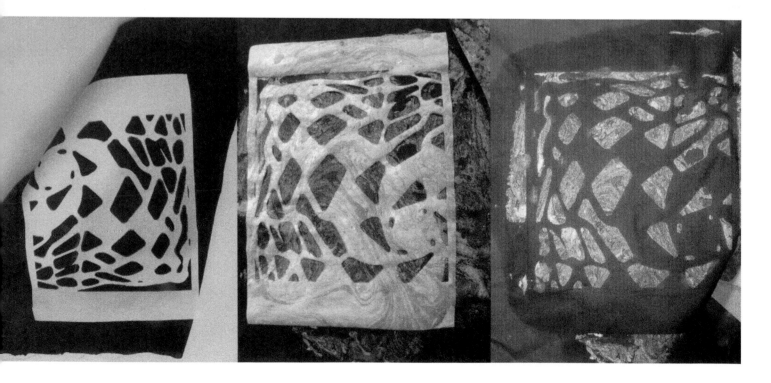

Commercial blocks and stamps

There are some good-quality blocks and rubber stamps available for use in Celtic design. Some of these are too intricate to be translated successfully into stitch, but a good source may be your local 'do-it-yourself' store, where stamps are intended to be used on walls and are consequently less fussy.

Use the paint range and colours as described on page 30, though you may find the need to be more inventive in the ways in which you use the stamp. Try painting just a part of the stamp and printing off a border in this manner. Overprinting may also be an option, but take care that it doesn't become too complex.

Computer design using a commercial stamp

An option for computer design may be to scan a print of the stamp made using black acrylic paint. Bring the scan into your design software and explore the options for colour masking. Choose to mask the black; this means that you will be able to paint colour anywhere except on the black stamped area. Try painting swathes of colour over the entire page, remove the mask and see the effect. Save the result. Now invert the mask so that the only place that can be painted is the stamped area. Using an airbrush tool to spray on colour means that some of the black remains, which gives a good effect. When complete, remove the mask, take a selection from the image, copy it, then paste it to a new page. Build up areas using the paste option.

The open, airy look of this method means that it will translate well into stitch using water-soluble fabric. Draw the outlines by placing the water-soluble fabric over the computer print (or over a print taken from the block) and drawing in the main lines. Then stitch with free running stitch, making sure that you stitch several times over the lines, or stitch a grid first to prevent it unravelling when dissolved.

Figure 37 A commercial block print, scanned into the computer, coloured and developed to make a border design.

Figure 38 A sample made using the computer designs above as a guide. Water-soluble fabric with free-machine embroidery was then stitched to a wire frame.

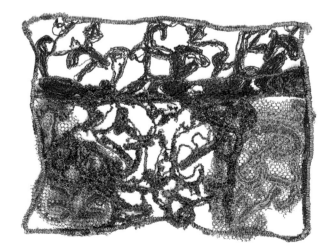

Twists and plaits

From the earliest times, people have been producing artefacts from twisted, plaited or knotted fibres. It is not surprising, therefore, that these have been copied as decoration. The earliest known twists and plaits date from Neolithic times, as witnessed by shards of pottery and the occasional intact vessel preserved from this period.

Twists were often constructed by using a pair of compasses to produce sophisticated designs long before their association with Celtic motifs. Ivory plaques from Assyria that show such motifs date from the 9th and 8th centuries BC. Unlike knots, there is not thought to be any symbolic significance associated with plaits and twists. Wonderful examples of twisted cable patterns can be seen in Roman mosaic floors.

Early medieval manuscript painting has become known to us as Celtic, although many examples have Roman, Anglo-Saxon or even Islamic influences. These show plaits and twists in addition to the more intricate ribbon interlacing. The metalwork of this period also shows these designs.

Although this form of design can be traced throughout history, it gained a very special place in the art of the Celts due to their use of break lines (see page 19). These enabled the designs to turn back on themselves, which adds to the intricacy of the overall design.

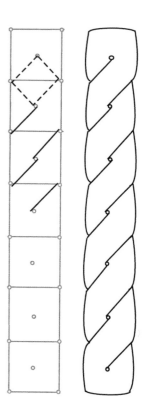

Figure 39 (right) Drawing a simple twist.

Figure 40 (below) Drawing a simple plait.

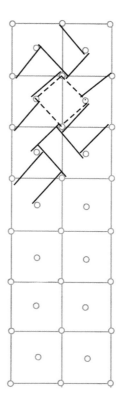

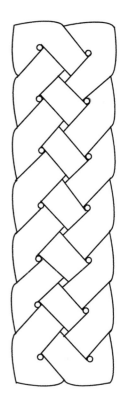

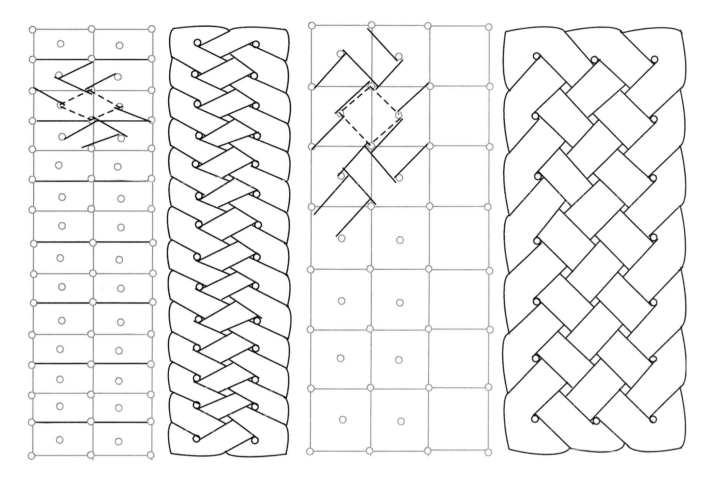

Figure 41 *Altering the proportions for a different plait.* **Figure 42** *Adding another strip to draw a four-strand plait.*

Plotting twists and plaits

Twists

A Draw a single band of squares, adding circles as in figure 39, following the same rules as described in Chapter 1.

B Imagine the dotted lines forming a diamond and draw the parallel lines all in the same direction along the length of the band. The lines can face either direction but must be consistent.

C Add curves and hooks, as for the knots.

Plaits

A Draw two rows of squares and circles.

B Imagine the dotted diamonds as before, and draw the parallel lines with further parallel lines at right-angles to the first pair (figure 40).

C Add hooks and curves.

Figure 41 shows a change of proportion; the horizontals are double the width of the verticals. Figure 42 shows a wider plait, following the same rules.

Distortions

The figure below shows a four-strand plait that has been distorted using the same method as described in figure 16.

Figure 44 (below) Adding break lines to a simple plait to separate the strands.

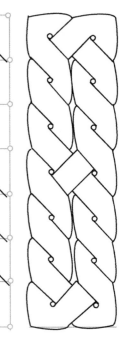

Figure 43 (above) Altering the proportions to change the plait.

Using break lines

The rules for break lines are the same as those described in Chapter 1 (see page 19). Remember that you cannot cross these break lines when plotting twists and plaits. Follow figures 44 and 45 and develop more of your own, remembering these rules.

Overleaf, the horizontal break lines shown in figures 47 and 48 produce a series of circles held together with straps. This can be developed to make a complete fabric (figures 49 and 50).

Figure 45 (right) Putting the break lines in different places for a different plait.

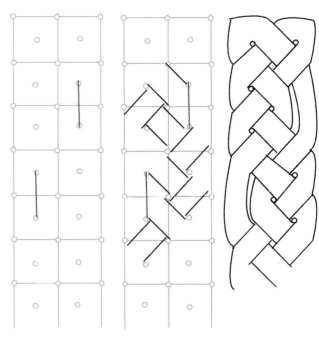

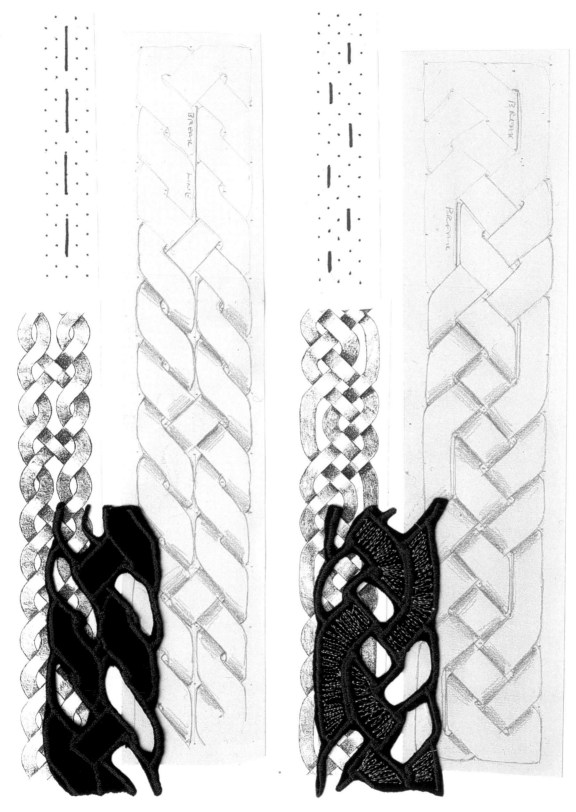

Figure 46 *Different interlacing patterns, with breaks placed in different places, and the stitched versions.*

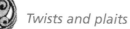

Figure 47 *Horizontal break lines give a pattern of circles.*

Figure 48 *Horizontal and vertical break lines give diagonal ovals.*

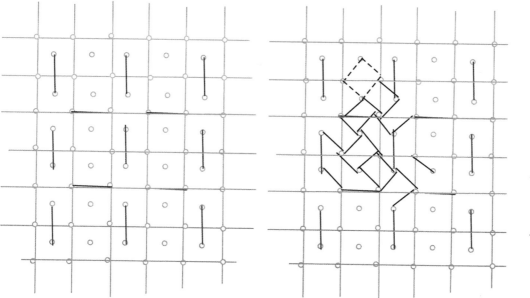

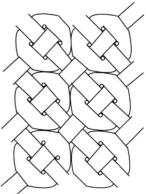

Figure 49 *Building on figure 47, with added vertical break lines, gives an all-over pattern of circles held together with straps.*

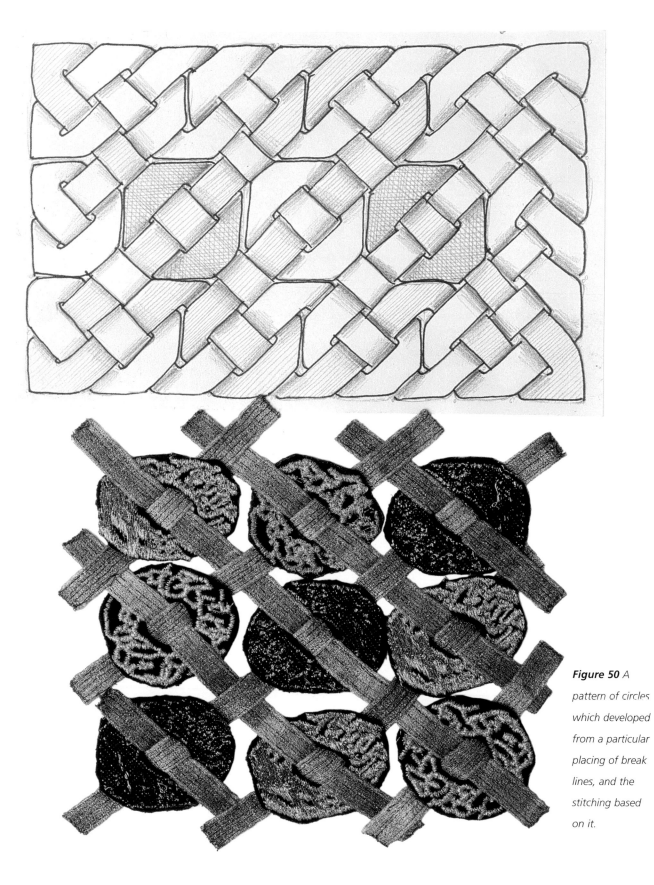

Figure 50 *A pattern of circles which developed from a particular placing of break lines, and the stitching based on it.*

41

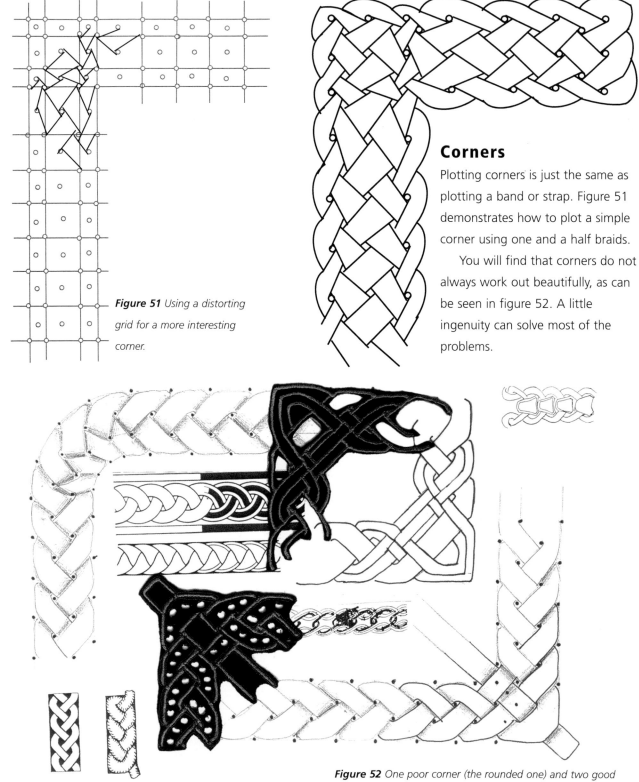

Corners

Plotting corners is just the same as plotting a band or strap. Figure 51 demonstrates how to plot a simple corner using one and a half braids.

You will find that corners do not always work out beautifully, as can be seen in figure 52. A little ingenuity can solve most of the problems.

Figure 51 Using a distorting grid for a more interesting corner.

Figure 52 One poor corner (the rounded one) and two good corner patterns with the stitched versions.

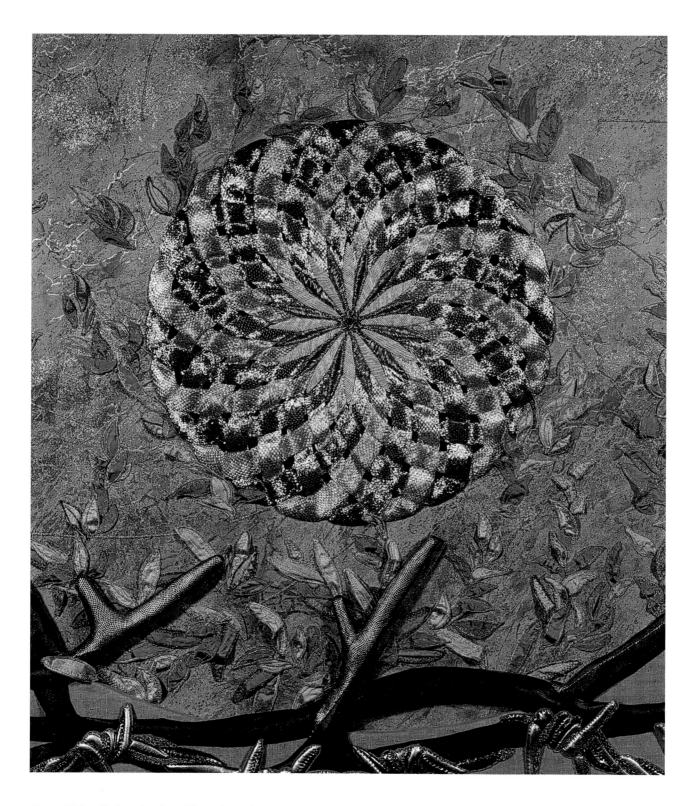

Figure 53 *Detail of an altar frontal from the Gethsemane Chapel, Bath Abbey. This chapel is dedicated to Amnesty International. The Celtic circle, with its interlaced design, symbolizes the interweaving of God's humanity, heaven and earth and spirit and matter. (Jane Lemon)*

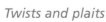
Designing from the drawings

In the same way that the drawings were used in
Chapter 1, these ideas can also be used to produce
designs that can be interpreted into stitch. The design
methods in the previous chapter all work well, as do
such techniques as card or string blocks. These can be
used for block printing, rubbings can be taken from
them, or, in the case of card blocks, the blocks
themselves may offer ideas suitable for stitching.

Figure 54 (right) A computer design using cable patterns layered
over each other, showing all layers.

Figure 55 (below) Watercolour flooded through a stencil,
emphasized with hatched lines in coloured pencil.

Figure 56 (below) Interlacing pattern using torn paper, flooded with
watercolour and emphasized with hatched lines in coloured pencil.

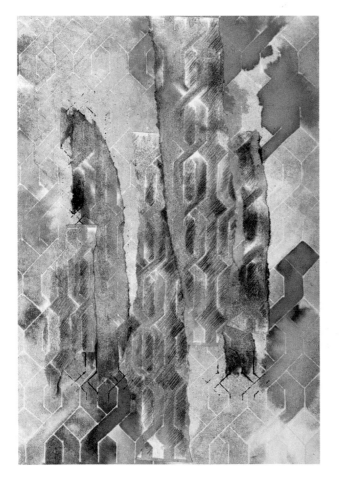

Card blocks

Using your drawing as a template, cut shapes from thick cardboard. You can do this by tracing the outlines onto the card. Don't make the shapes too complex. Cut them out using a sharp craft knife, taking care to cut away from your body. Now cut a further square of thick cardboard and, using contact adhesive, glue the shapes onto this so that they make a pleasing design. Leave under a weight overnight and the shapes will stick firmly. This will produce a block that can be used for printing. It should be sealed with varnish or dilute PVA (white craft glue) and allowed to dry.

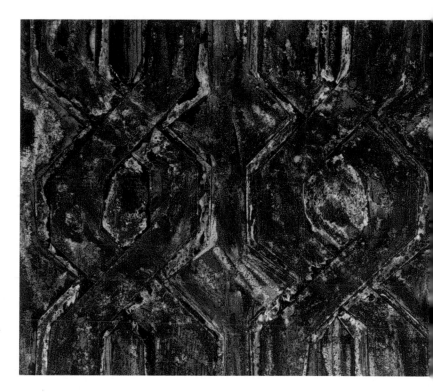

Figure 57 (right) *Thick card shapes glued to card and rubbed thickly with wax crayon. The whole pattern was covered with writing ink, dried, and then painted with bleach.*

Thermoplastic printing blocks

Thermoplastic foam is sometimes called Softsculpt, Formy or Formafoam. It can be heated and then pressed hard onto a carved or moulded surface to take the shape of that surface. For instance, pressing it onto a carved wooden block will result in a negative image of that block. This can be useful when using the two together, perhaps side by side, although the foam print will be softer and slightly more abstract.

Anything can be used to texture the block. A cheese grater, for example, can produce a great background texture when printed on fabric. Also, look out for plaster or resin artefacts – a Celtic cross with an interesting pattern was found in a cathedral shop sale and used to produce blocks. Often ornaments, boxes and the like, with a raised Celtic design, can be found at car boot sales (garage sales).

To make your block, cut the foam to the required size. Heat it by placing in a low oven (follow the instructions on the pack) or use a heat tool or iron with baking parchment (silicone paper) between the foam and the iron. When sufficiently hot (do not overheat), immediately press onto the block or textured surface, or press the block into the foam if this is easier. If the impression made is not deep enough, you can reheat the foam and try again. When you are satisfied, glue the block to a piece of thick cardboard of the same size for ease of use. Make a handle on the back with sticky tape to make it easier to handle (figure 58). All the printing methods described overleaf on pages 46–49 work for these blocks.

Figure 58 A handle for a string block.

Figure 59 *This plaster cross was found in a cathedral shop. It proved very useful for impressing patterns into thermoplastic blocks.*

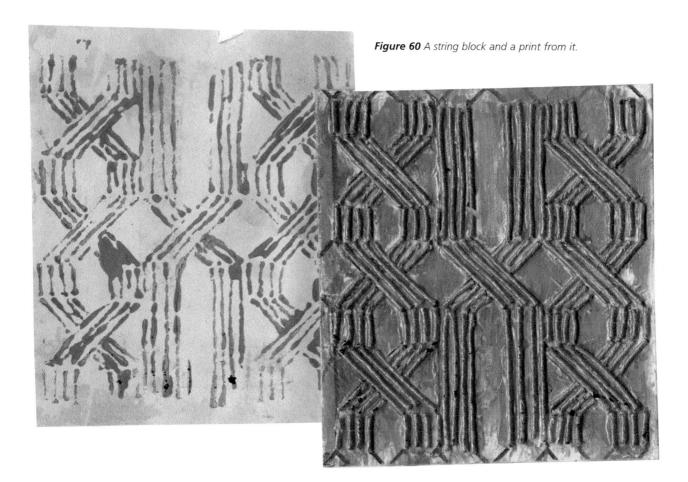

Figure 60 *A string block and a print from it.*

String blocks

Make sure that your drawing is not too small and fiddly. Stick a copy of the drawing onto card using a spray adhesive. Cover this with double-sided sticky tape and peel off the top covering, leaving a sticky, see-through surface. Using a firm string, stick lengths of it to the sticky-tape surface, following the design. Don't overlap the string. Cut it and start again when the line goes over or under itself. When you have completed the blocks, seal them with two coats of PVA (white craft glue).

This method is also good for computer printouts. The original drawing could be resized or distorted in a paint or draw program, printed and then stuck to card, as described on page 45, to make a string block.

Printing with blocks

The blocks can be used to make prints on paper or fabric. Take a sheet of thick polythene or glass and spread paint on it with a brush. The paint layer needs to be thick enough to be taken up well but not so thick that it results in splodges. Put the block face down onto the paint layer and then place carefully on the paper. Make a little pad of fabric or kitchen towel to place the paper on. It is best to make the first couple of prints on scrap paper, as blocks need to be used a couple of times to get them working well. Acrylic paints have a good consistency for block printing and work well on fabric as well as paper. Make background papers as before and print over them with the printing blocks. Try overprinting with gold or metallic paint, but make it a very fine layer or it can look messy.

Using a photocopier

It is possible to buy foils that fuse with the toner from photocopiers or some laser printers. These can be used to great effect when preparing designs. Just print from your block in black acrylic on white paper and then photocopy the result. Lay the foil, shiny side up, over the copy and iron (keep the iron at quite a low heat, about a silk setting), to transfer the foil to the photocopy. Use the toe of the iron unless you want to cover the whole of the toner area. Wash colour over the area after foiling.

Rubbings from card or string

Transferring the design from the block by making a rubbing offers the chance to bring in all kinds of media. For example, holding paper firmly over the block (or even taping it over to make sure that the block doesn't move) and rubbing with wax crayons provides a surface that can be enriched using paints or inks.

Wax crayons act as a resist to paint, which offers lots of possibilities. Other media to use could be Markal (Shiva) oilsticks – oil paint in a solid form. These come in lovely metallic colours and also act as a resist. Wax candles will form a resist to paint when rubbed over a suitable textured surface such as a string block.

Overpainting

All these resists give fabulous results when washed over with paints or inks.

Just as there is a wide variety of crayons or oilbars available to use for rubbings, so there is a choice of media that can be painted over the rubbings. These could be Brusho (a powdered ink), watercolour paints, inks or Procion dyes. The dyes give wonderful colours, while inks give a subtle shine. Try painting in several colours, in bands, grids or random patches of colour.

Try using a wide variety of papers, from cartridge to tissue paper, although cartridge paper may be a little thick for the rubbing to work successfully, especially with a string block. Black, Quink-type ink could be used and then bleached. The bleach may need to be watered down, so sampling will be needed to get this effect just right. A sponge could be used for the bleaching.

Black tissue paper will often bleach very well, so try rubbing the block with a black wax crayon and then bleaching it. The bleach will creep under the wax to give a range of interesting effects. Markal (Shiva) oilsticks would work well in this situation, too. With all these methods, a layered effect could be produced by making random marks with a wax candle on the finished print and adding further washes of colour.

The designs could have additional spongings of gold metallic paint. Black or gold webbing spray could be used – this can be wonderfully effective. Drawing back into the design with a gold pen, perhaps highlighting certain areas or using marks that could translate to stitch, is also a good way to add emphasis to the piece. Embossing powders, which are available from rubber-stamp shops or suppliers, can be sprinkled over while the ink from the gold pen is still wet. They can be heated with a heat tool to give a raised and textured effect. The powder is also very good with webbing spray, but you have to move quickly to sprinkle the powder before the spray dries. Shake the excess powder back into the pot before heating with the heat tool.

A black-and-white computer print or photocopy of the original rubbing can also be painted and worked into as described above.

Any of these designs may be enhanced by emphasizing some of the lines using coloured dimensional paint or glue to give raised areas. A glue

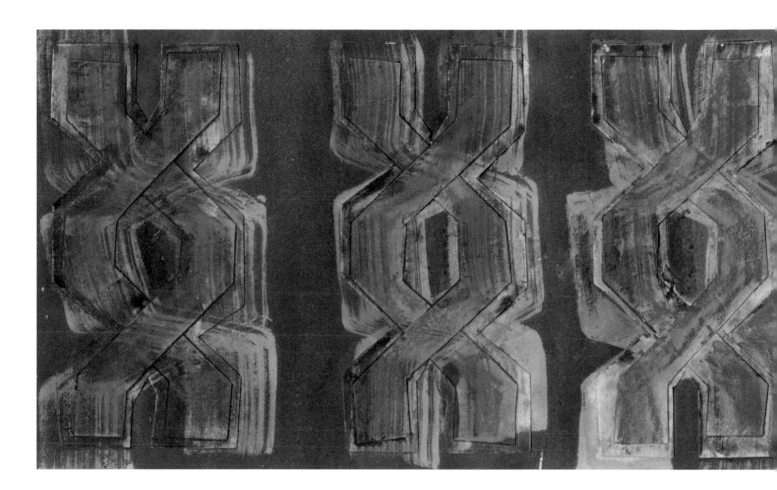

Figure 61 *Cut paper shapes glued to card and rubbed with coloured wax crayons. Writing ink was painted over the whole thing and then partially bleached.*

gun could be used to add even more definition. Allow the gun to heat up so that the glue flows easily, and then draw with it onto the block, following the lines of the plait, adding swirls as required – the process is a little like icing a cake. The glue produces fine filaments, which look very attractive when painted. Paint when dry with acrylic paint and add metallic paint or wax when the paint is dry.

All the above ideas for rubbings will work with both card and string blocks, and it is worth looking for other surfaces from which to take rubbings. See pages 50–51 for some more ideas.

Using the card block as inspiration

A further consideration with card blocks could be the idea of using the block itself with a resist such as wax crayons or Markal (Shiva) oilsticks, and then flooding with ink. Bleach lightly into the ink and allow to dry. Highlight the raised areas with gold metallic paint, used very sparingly, or gold wax such as Treasure Gold or Liberon. PearlEx powders can be brushed over the wax for a wonderful burnished effect. If you intend to use the block in this way, do not paint it with PVA (white craft glue), as this would seal it and prevent it from taking up the colour.

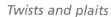
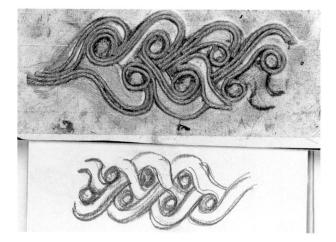

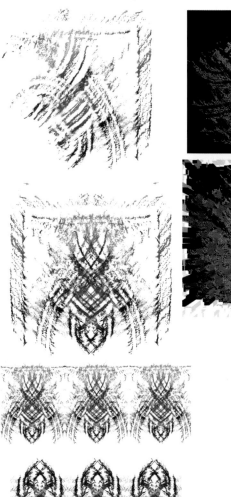

Translating the designs to stitch

Using blocks and rubbings

One of the most obvious ways to translate the designs is to use the card or string block as a surface for a rubbing on fabric rather than paper. The sticky surface that holds the string down will obligingly grip light fabric if you press it down well. You can then rub with ChromaCoal pastels (see page 70), fabric crayons or Markal (Shiva) oilsticks, and the fabric will not budge. Rubbing a card block may require that both the block and the fabric are taped to a surface before rubbing begins. Don't overlook the possibilities of fabric rubbings on those commercial Celtic tiles and plaques, but be aware that the Markal may seep through the fabric and stain them.

Figure 62 (above) String block made from a sketchbook drawing. A rubbing was made from this using ChromaCoal pastels on painted fabric. Further stitching was applied to this.

Figure 63 (left) Rubbings from a Celtic ceramic tile scanned into the computer, coloured, and repeated to make patterns.

The rubbings could also be overpainted with silk paint or watered-down fabric paints. They would then be ready for stitching by hand or machine. It would be possible to stitch all over, perhaps lines of running stitch, by hand or machine in straight stitch or a not-too-obvious pattern. This would give an excellent base for further stitching.

The colours of the design should be used to translate it to fabric. For instance, the inked and bleached pieces could be stitched on a fabric that responds to a bleaching agent or discharge paste, as described on page 30. Gold fabric paint could then be added, with highlights of gold thread. Many of the designs cry out to be machine-embroidered. The fabric with the rubbing on it could be backed with a heavier one to allow fairly solid areas of machine embroidery to be worked.

Card blocks could be printed onto nappy (diaper) liners, placed over a painted background. The main lines of the block could be outlined using free machine straight stitch and the piece could then be 'zapped' with a heat tool.

The painted, bleached and gilded card blocks certainly give good ideas for heavy free-machining on black felt, cutting the pieces away from the felt and building them up over a background. More stitched pieces could be placed over the top and built up to match the design. Tiles could be made in this way and stitched to the background fabric as a repeat pattern.

Figure 64 (above) *Parts of the rubbings were enormously enlarged, coloured and filtered in different ways. Sections were placed together as a collage and printed onto computer print fabric as a background.*

Figure 65 *Stitching based on the rubbing of the tile in figure 63.*

Decorating individual straps

The straps used to form plaits and twists in Celtic design were often richly decorated. Some of the papers from the rubbing experiments could be cut into strips and plaited. The marks formed by the rubbings can be interpreted using embroidery. The resulting embroidery could also be cut into strips and plaited. The plaits themselves could then be stitched down, perhaps merged into the background with further stitching so that they stand proud. Alternatively, the papers could be cut out to match the string block and stuck to a background to make a design. This could be interpreted using felt, which can be stitched with automatic patterns and have similar shapes cut from it, ready to apply to a background.

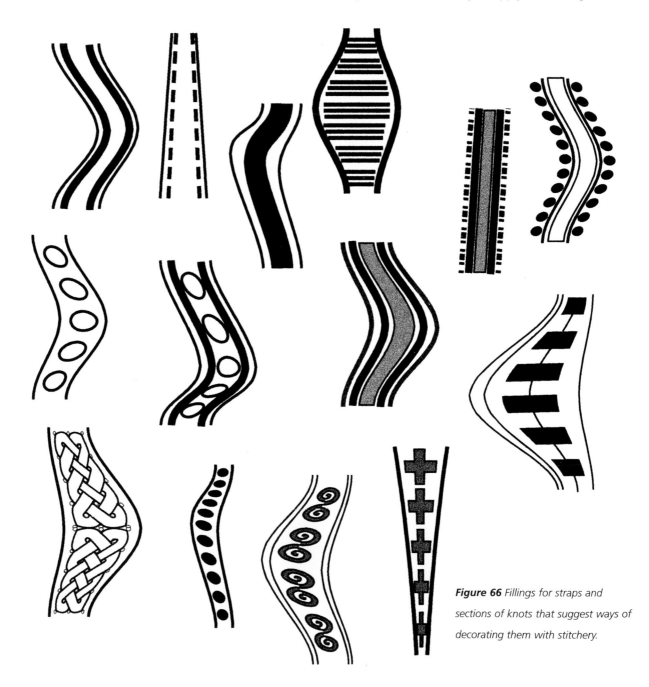

Figure 66 *Fillings for straps and sections of knots that suggest ways of decorating them with stitchery.*

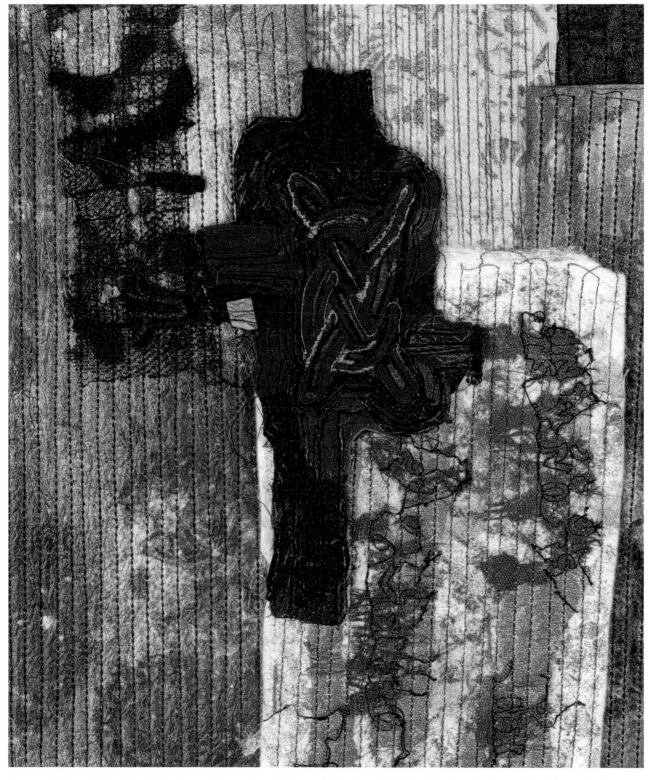

Figure 67 *An applied, stitched, knot was laid on a shaped piece of fabric. It was backed with painted and stencilled fabric, and then contour lines of whip stitch secured them all. The surface was further broken with stitching on net, and random free running.*

Free-machined cut-outs

Free-machine the plait, or parts of the plait, onto felt or a heavyweight Vilene, painted before stitching. A narrow satin-stitch border could add definition. When stitching is complete, it can be cut from the fabric and applied to one of the backgrounds made from the rubbings, or it can be repeated to form part of a stitched background.

This technique could be taken further and the stitching designed to plait or twist together after cutting out. Further interest could be added by threading buttonholed rings into the twist when it is put together. Borders can be made using this method.

If your machine has some large automatic patterns, these could be cut out and plaited or twisted together. Even the smaller patterns can often be used alone or plaited together to form a bumpy strip that is suitable for using as a border.

Some machines have plait or twist patterns that are ideal. Most have patterns that can be adapted. If the patterns are stitched onto a suitable synthetic felt, the strips can be 'zapped' with a heat tool before plaiting. The only way to tell if a felt will react to the heat is to try it before you stitch, but do remember to wear a mask or, preferably, a respirator before heating. The felt sold as Kunin felt will almost always react in this way. However, there are odd colours that don't, so always test before doing a lot of stitching.

The cut-out patterns or plaits can be laced over narrow card, previously covered with some of the rubbed fabric. Do this by stretching fabric over narrow strips of card and lacing tightly at the back. If the two long sides are laced, the shorter edges can be turned in and hemmed. When the strips have been wrapped around the covered card strip, it can be applied to a backing fabric to form bands of pattern. Open strips between the bands can be stitched by hand or machine.

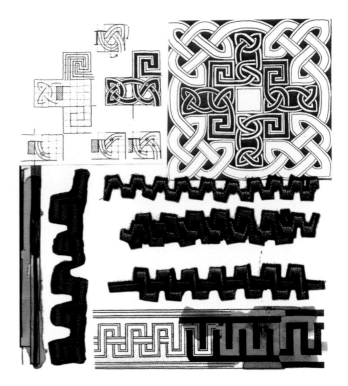

Figure 68 *Freely stitched patterns were interlaced to make cable patterns.*

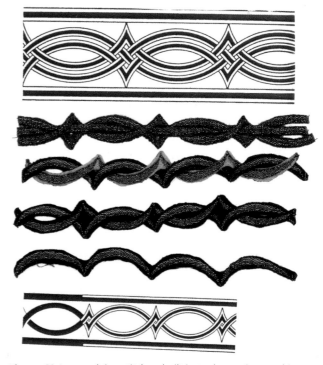

Figure 69 *Large edging stitches, built in to the sewing machine, were interlaced to make cable patterns.*

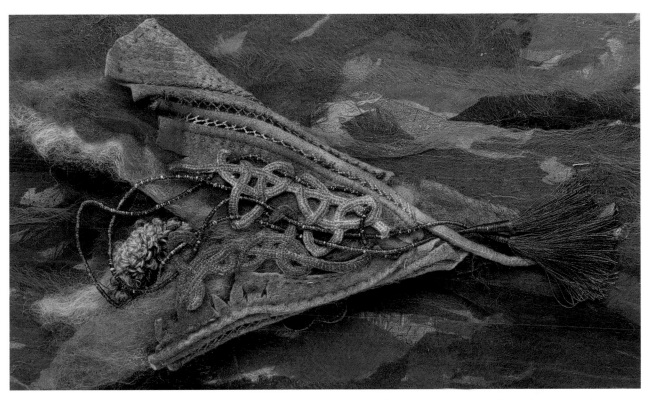

Figure 70 *Celtic Corset Vessel. The design was based on a motif from the Book of Durrow. The piece uses hand-dyed silks and handmade felt which has also been dyed. (Jill Nicholls)*

Cut-out strips or wrapped cords could be used to lace two strips of fabric together. Eyelets or buttonholes can be made to pass these cords through, and the interlacing could form a major part of a panel, cushion or bag.

Stitching to distort

Really solid stitching can distort a fabric into almost any shape and can be used to form twists, as follows:

A Bond a piece of cotton fabric to felt.

B Mark a line of five 2.5cm (1in.) squares, as shown in figure 71.

C Use two threads through the needle and tighten the top tension slightly.

D Stitch each square separately in the directions shown in figure 71 (left). The stitching should be really solid so that it completely covers the fabric.

E Make another strip in the same way and cut them both out. Burn the edges with a candle in order to seal them.

F The two strips can then be wrapped around each other to make a twist.

Figure 71 *Stitching a straight strip of fabric in different directions (below left) to distort it into a different shape (below right)*

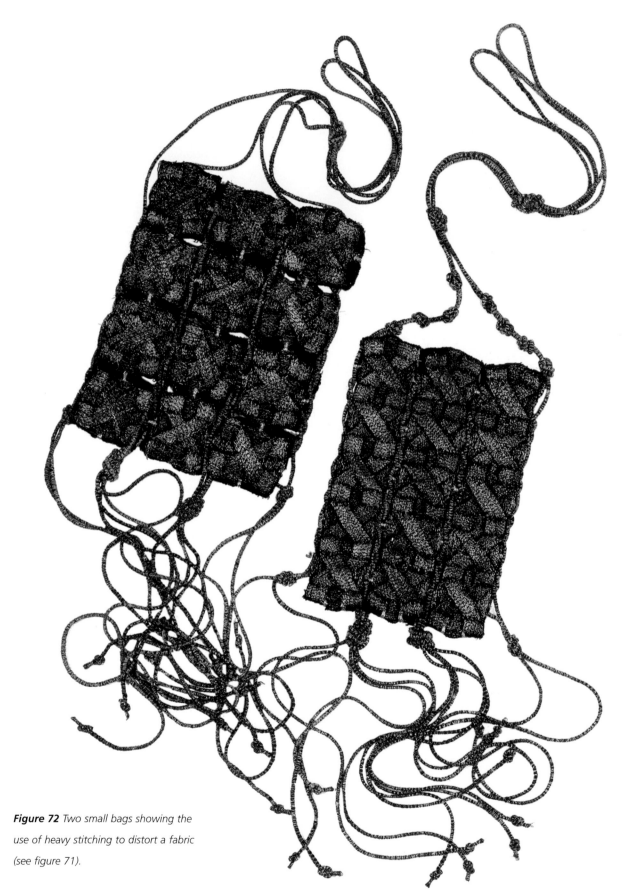

Figure 72 *Two small bags showing the use of heavy stitching to distort a fabric (see figure 71).*

Circular sewing attachment

Many machines have a circular stitching attachment. Interesting strips can be made from these if a large circle is set. Stitch only part of the circle. The strips will have a gentle curve, which will add movement to a plait or twist. Try using this attachment with some of the built-in patterns. Experiment to find the best ones to use. Additional interest can be given by stitching on felt and zapping the strips (see page 54). Strips could be built up to form waves or arch shapes and applied to background fabrics. They could be woven together to form an undulating surface. It is interesting to note the difference between the built-in patterns as straight stitching using the ordinary foot, and those produced using the circular stitching attachment.

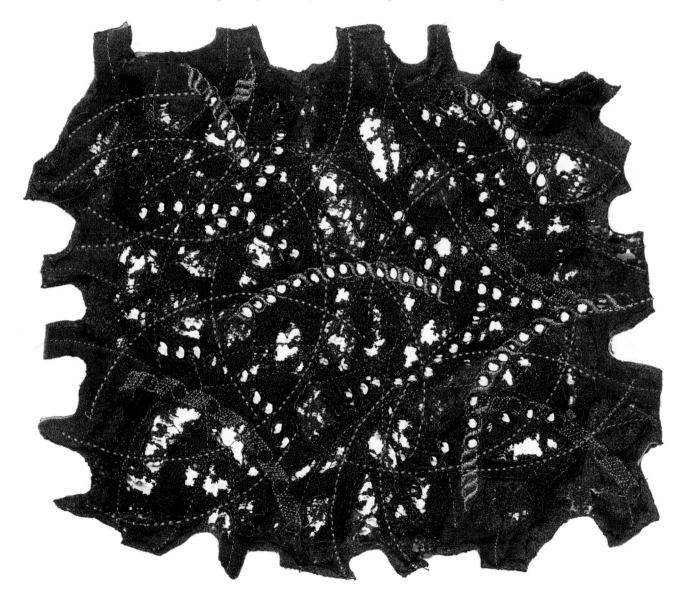

Figure 73 *A fabric was worked with lines of an auto pattern using the circular stitching attachment. Cables were worked, also using the attachment, cut out and applied on to further curved lines of straight stitch which blended the piece.*

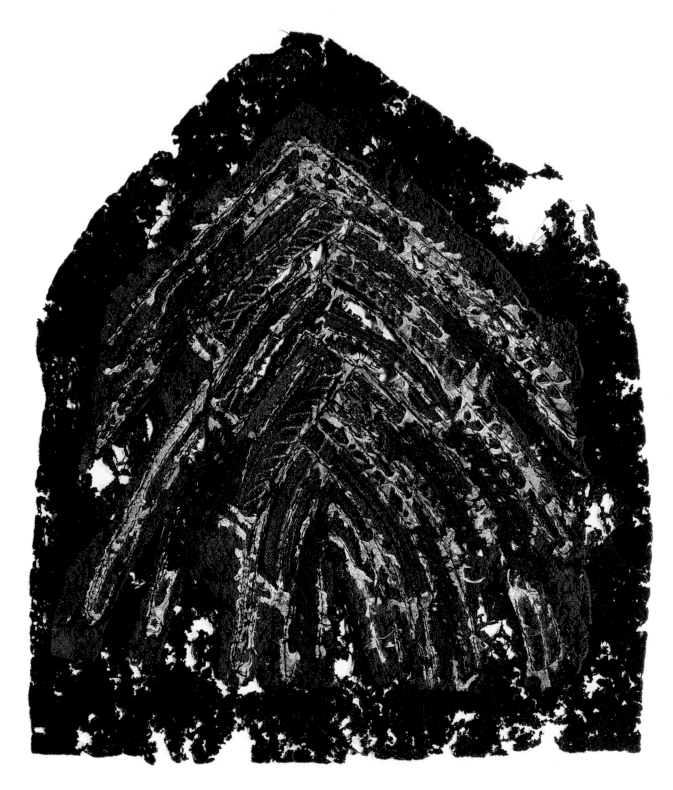

Figure 74 *Newspaper was laid on felt, stitched in curves using a circular stitching attachment, wet and partially rubbed away. Curved lines of auto cables, also using the circular stitching attachment, were cut out and applied. A heat gun melted the felt into holes for a delicate, lacy border.*

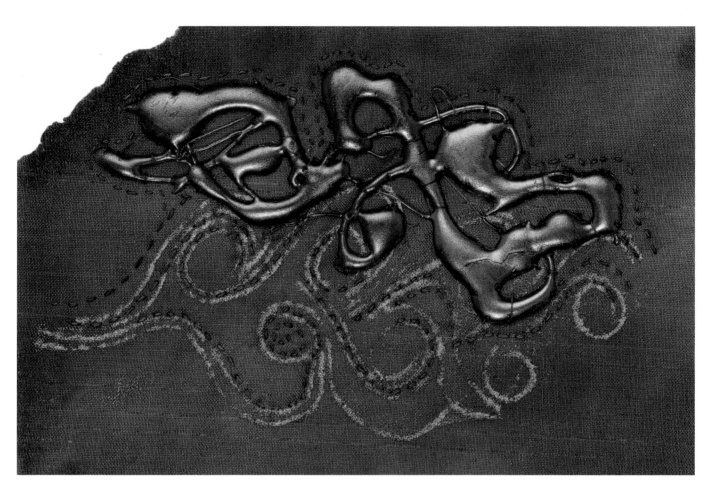

Figure 75 *Glue gun motifs, coloured with wax have been stitched to this quilted fabric.*

Woven strips

Frames can be made from wire coat-hangers held in shape with strong plastic tape. These can be wrapped in each direction with a strong yarn or cord. Strips of machine embroidered fabric, cut-out plait patterns, or even the plaits or twists themselves, can be threaded through the resulting grid. The whole piece could then be machine embroidered to hold it together. This could be embellished with further machining, or beads could be added. Finally, the piece is cut from the frame. The uneven edges can remain, as they are often very attractive. This technique makes great cushions and book-covers. See figure 79 overleaf.

Glue gun on fabric

Go back to your designs made using the glue gun (see page 48). This glue can be used on fabrics too, if the motifs are painted or waxed. It can be applied directly to the fabric but it is probably best used on baking parchment (silicone paper). Do a rubbing or trace your design onto the paper. Follow the design as best you can using the heated glue gun – you won't be able to follow the lines precisely, and this enhances the result. Allow to dry, then peel off and paint with acrylics or rub with wax. The wax is easier to use and is very effective used with PearlEx powders. Stitch the shape to the backing fabric taking the stitches through the set glue. Alternatively, couch it by going over the narrow areas with a heavier thread.

Spirals, scrolls and meanders

Spirals are found everywhere. They can be traced from the remotest past, from the earliest primitive tribes, to the most sophisticated art forms. The spiral can be found in nature, where many different forms – such as the markings of a snail shell or the highly curved fronds of a fern – can be determined through similar mathematical processes. Spirals form in water, from the ripples of a cast stone to the more mundane water down the plughole. It is no wonder, then, that people have always seen spirals as having a mystic or spiritual meaning. This has formed the basis of many religions, which see the whirl as a cosmic force or a symbol of eternity. The motif can be traced back to Palaeolithic times and can be seen in carved bone artefacts found in France, in the wonderful carvings on the entrance stones of the Newgrange site in Ireland (figure 76) right up to the paintings of Gustav Klimt, the work of the Art Nouveau movement and the designs of today. Jungian theories use the spiral as a demonstration of man's journey from the unconscious to the conscious mind. So, we can see that the simple spiral – essentially a line curling inwards to a centre point – can represent power, cosmic forces, creativity and growth, both spiritual and physical. In Celtic art, the line is often seen as travelling to the centre and then doubling back on itself to give a double spiral effect. Other effects can be classified as meanders, where the line passes from edge to centre, and then out again and on to the next motif in a repeat, often angular, pattern. Key patterns developed from these meanders. They are square, more geometric versions, and are often used in Celtic art to fill spaces.

Figure 76 *(above) Drawings of spirals from a kerbstone at Newgrange, Ireland.*

Figure 77 *Squared-off meander patterns, which were also used by other artists in other periods. It is often called a Greek key pattern.*

Figure 78 *Part of a key pattern that was scanned into the computer and stitched.*

Further developments by the early Celts took such motifs as the lotus and palmette, common in the Mediterranean area, and combined them with spirals and scrolls. Working these in pairs and using symmetry within the design, they formed whirling patterns such as the triangular, trisceles forms. ('Trisceles' is a specific term – with several variations in spelling – referring to the shape shown in figures 80 and 100 on pages 62 and 73 respectively.) Many of these designs, also combined with elaborate trailing tendrils, were used for the decoration of swords, scabbards and shields. Later designs combine the spirals and scrolls with Anglo-Saxon art and this may have resulted in the zoomorphic spiral designs often seen in illuminated manuscripts of later Christian art.

Figure 79 *(above and below) Lines of auto patterns were stitched on felt, then holes burnt with a soldering iron and cut into strips. Another fabric was covered with an enlarged version of the same pattern and also cut into strips. A wire frame was wrapped with zigzagged cord and the strips woven through. Finally, small key pattern motifs were applied on top.*

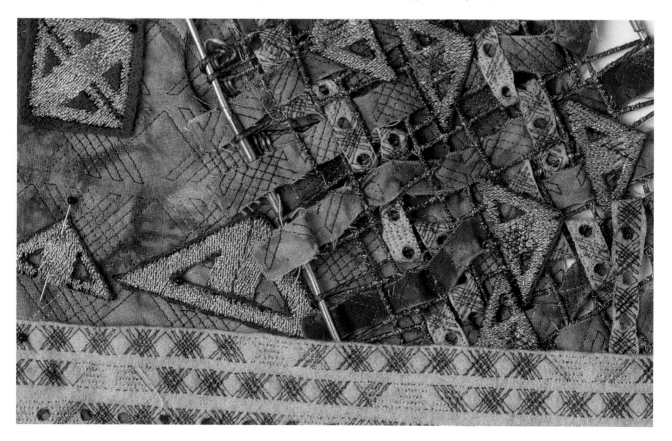

Many reference books show examples of Celtic art. Buy or borrow one of these and look closely at the motifs. Practise drawing spirals freehand – they are wonderfully liberating. Draw with a thick felt-tip pen and don't worry if they are not perfect. Think 'stitch' and try drawing different sizes and thicknesses, which could be used to translate into stitch. Think 'free running' using a continuous line. Try whip stitch or satin stitch, couched threads, or any of the many linear hand stitches. Any of these can be used to build up backgrounds or areas of stitching to make an understated fabric suitable for further, more emphatic, stitching to give definition.

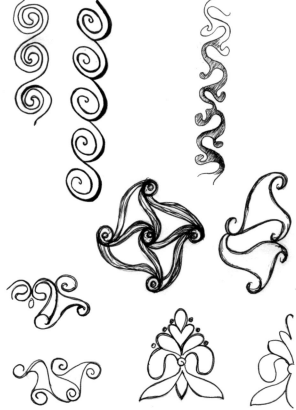

Figure 80 Sketches of trisceles, meanders and palmettes.

Other designs for stitching could be produced by drawing an outline – this could be a felt-tip pen drawing over painted paper – and using various means of filling the shape. Make small 'stitchy' marks within the shape, or fill in a shape with solid colour and then dab with correction fluid or white acrylic paint to fragment it.

A good idea for drawing symmetrical motifs is to just draw one half freehand, and then trace this. Flip the tracing over to complete the drawing. This method was used to draw the palmette motif in figure 80. If you have access to a computer, these half-drawings can be scanned, flipped and copied in the same way.

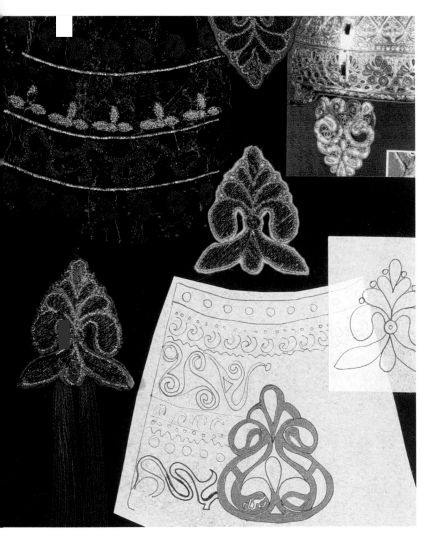

Figure 81 Design board showing the source material (a French helmet) and various samples, including a tassel made from a motif isolated from the material.

Computer design

The computer can be a useful tool, especially for Celtic design. There are special programs for designing with Celtic motifs, and fonts can be purchased that give a particular type of lettering, or produce spirals and roundels. The Internet is a rich source for these things.

Computer design can be combined with conventional methods, as shown in figure 82. To produce these patterns, a drawing of spirals and meanders was scanned into the computer and then enlarged and reduced to produce designs suitable for embroidery. In figure 83, black crayon was rubbed over a string block made from the design onto black tissue paper and then bleached.

Figure 84 demonstrates how the same design can be printed or photocopied using a black-and-white copier. The photocopy was dabbed with coloured ink using a sponge. Ink was used because of its transparent qualities. When the ink was dry, the pattern was redefined by using bottle paint (the kind that comes in a small bottle with a nozzle).

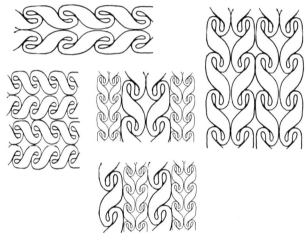

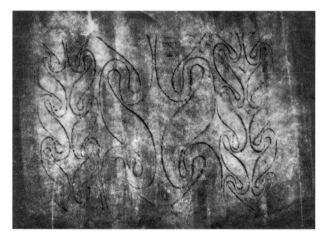

Figure 82 (above) A simple meander that has been developed by repeating and mirroring it – a change of scale is always effective.

Figure 84 (below) Prints of the meander pattern were painted with transparent inks and parts of the pattern emphasized by drawing with bottled paint.

Figure 83 (above) A string block was rubbed using black wax crayon through black tissue paper and then painted with bleach.

Figure 85 (below) A scrunched dyed fabric overprinted with solid and line patterns.

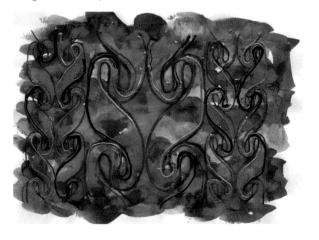

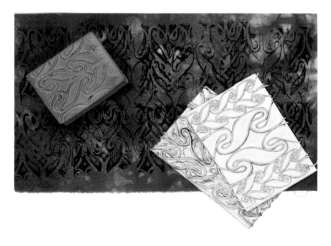

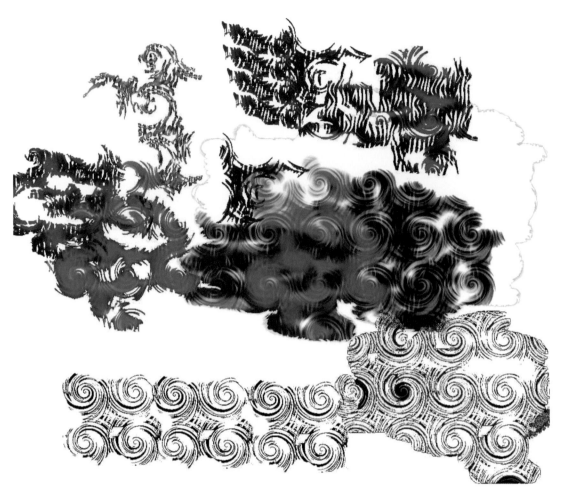

Figure 86 (above) *A fragmented computer design using built-in textures, selected by the Magic Wand. The black-and-white version was taken into the sewing machine software to be stitched.*

Figure 87 (below) *The design obtained using the Magic Wand has been digitized using sewing machine software, and stitched on painted fabrics.*

A simple outline drawing can be taken into a paint or draw program and distorted using special effects. This makes an excellent base for block printing. Many paint programs have built-in texture or paper type, and lots of these have spirals in some shape or another. If these are used as a background to a variety of paint colours, the Magic Wand tool can be used to isolate areas of the design. This will fragment the patterns and a delightfully wispy design can be built up, which may give ideas for using soluble fabric or vanishing muslin in a particular way. If you have a sewing machine with its own software, you will be able to take the designs into the program and stitch the fragmented areas out.

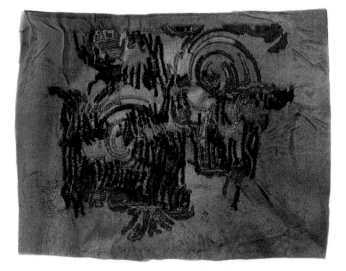

Figure 88 *A vessel made from acrylic felt and Wireform which has been stitched with spirals and zapped with a heat gun. The pieces were then joined and folded to form the vessel.*

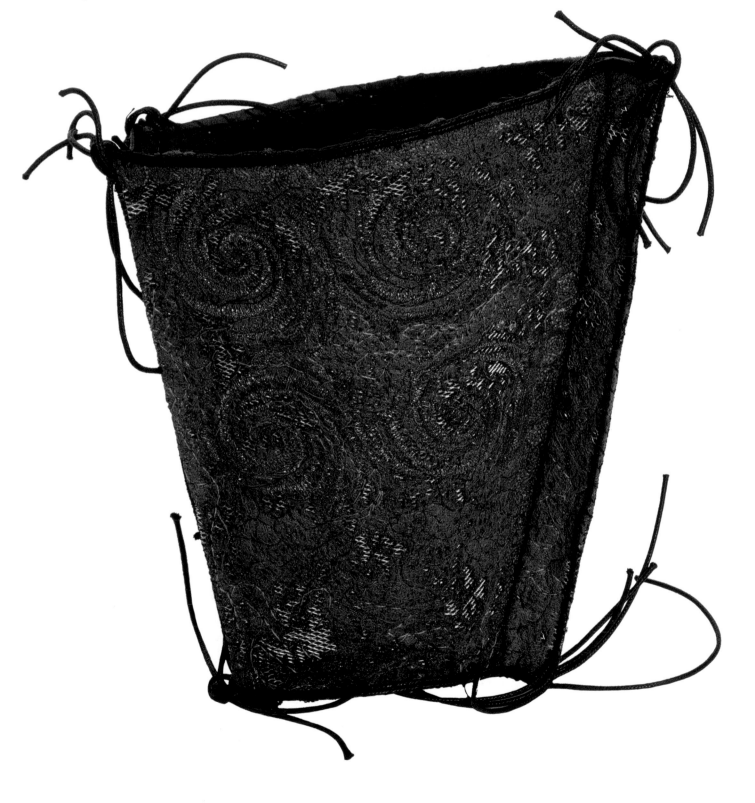

Some of the computer filters offer the option to draw or drag a brush through a design to make random, marbled spirals. There are also some special effects that completely cover a design with pinwheel shapes. These are a little obvious, so try to use them in a more imaginative way, perhaps using the Select tool or the Magic Wand first, to highlight just one part of the image. Then apply the effect and it will alter just that small area of the screen. This gives a much more subtle and intriguing effect.

Figure 91 shows the use of a spiral font, and it is well worth investigating the available Celtic fonts. Bring them into a paint or draw program, colour them or use the program's special effects, and you may find that they suggest embroidery techniques, sometimes ones that may not have occurred to you.

Many draw programs have built-in options that may enable spirals to be drawn, varying the size and to some extent the shape. The Transform tools here can be used to good effect.

Figure 89 (above) Spirals were put through different filters on the computer to suggest ways of using them in embroidery, with painted and transparent fabrics and simple stitchery.

Figure 90 Parts of spirals and palmettes were traced and rearranged to make a new pattern on a background which could be made from painted Bondaweb.

Figure 91 (right) *A computer font in which each letter is a different spiral.*

Figure 92 (below) *Stitched versions of one of the letters in the spiral font.*

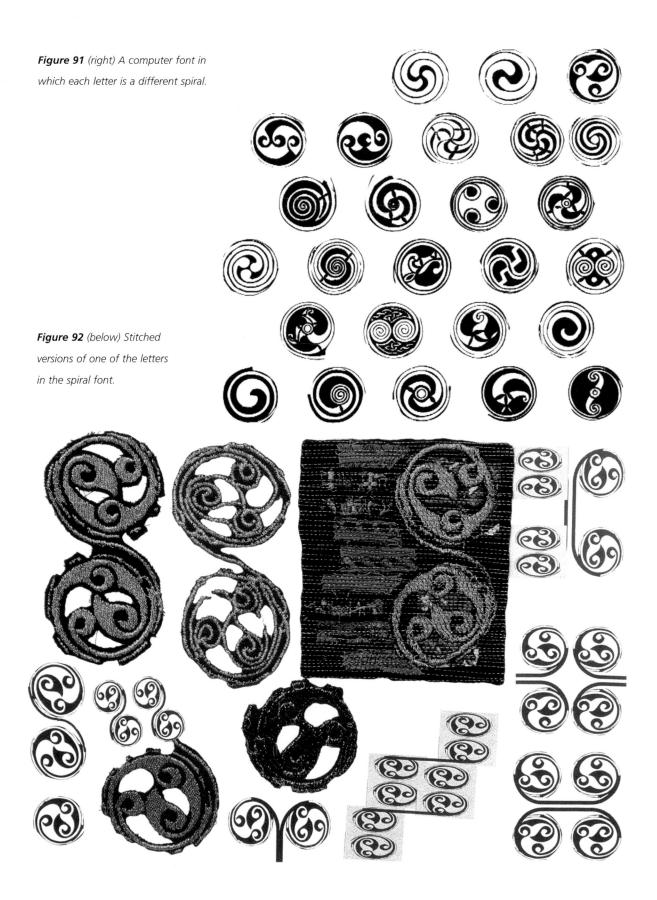

On to design

When you have a good selection of spiral drawings or ideas in your Celtic sketchbook, think about ways to extend and use them to prepare designs for embroidery. Many of the previous design techniques will prove useful. In fact, any of the design methods from the first two chapters will work well, but here are a couple more to extend your repertoire.

Pressprint

We covered block printing in Chapter 2, but Pressprint brings its own characteristics to this technique. It is a light polystyrene sheet with a smooth, flat surface. To use it, place one of your spiral drawings or designs over a square of Pressprint and draw around the main design lines with a pencil or spent ballpoint pen, pressing quite hard. You will probably wreck the drawing in the process, so use a copy, not the original. When the main lines are transferred, remove the drawing and go over the lines again. They should be quite deeply incised. You could use a soldering iron lightly (wear a mask or respirator), making sure that you don't go right through. When the main design is inscribed, add some detail in the background; just stippling with a pen or pencil gives texture. Try cross-hatched lines, especially around the edges, as a border.

To print with the block, make a handle by sticking a piece of tape on the back (see figure 58 on page 45). Now roll out some paint onto glass or polythene using a roller or sponge brush. Acrylic paint usually has a good consistency for this type of block printing. The paint should not be too runny. Try rolling two or three colours, placing blobs of paint side by side on the polythene. It is essential to get the paint layer right. If it is rolled too thinly, not enough paint will be taken up by the block. However, too much paint is worse and will clog all the lines in the block. Err towards

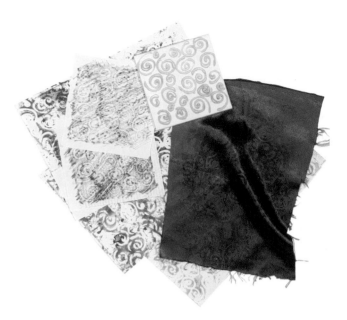

Figure 93 Scrolls drawn with a biro on fine polystyrene used as a printing block.

spreading thinly at first. Place the paper that you are going to use on a little pad of kitchen paper or fabric. It will print much more clearly on a soft surface but, before you do this, print the first one or two onto scrap paper or newspaper. The block will be better when it has been used a few times.

When you are ready to print, place the block face down on the paint and then carefully print onto the paper. Place prints side by side in a repeat pattern. You will probably need to replenish the paint after printing a few blocks.

When you have got the hang of the printing process, try printing on black paper. You will need a light colour in the mix for it to show up. For instance, try red and yellow together, or mix a colour with white to lighten it. Black backgrounds have a dramatic effect, but the colours need careful thought.

Think about colour contrast: a dark blue over a paper previously painted in zingy, bright colours will give a good effect, for instance. A contrast of warm colours (reds and oranges) on a pale background (cool blues and purples) should work. It is very good colour-theory practice to keep a record of colour over colour. Try overprinting with a metallic effect. You can mix your own using bronze/gold powders or lustre powders with a special medium that binds the powders and makes them suitable for painting. Try the metallic effect on black paper or on previously printed papers. If you have a computer design program, you could scan in a printed block on a white background and then use the program's Paste Transparent option, trying it over a variety of backgrounds prepared using the paintbrush tool.

Pressprints on fabric

The method for printing block prints on paper can also be used on fabric. Make sure that the fabric is smooth and not crumpled. Most smooth surfaces will be suitable. Follow the same rules as for paint and for the use of colours. Do try out the metallics on fabric, especially on dark colours.

Stitching into prints

Exciting effects can be obtained by using fabric transfer paints and crayons. These can be printed on paper using the block and then ironed onto synthetic fabrics. The fun starts when colours are overprinted, giving unexpected results. They can also be sprinkled with salt, when newly printed, for a textured effect. Because it is difficult to judge the colours, especially when overprinting, do some experiments, noting the colours that were used for future reference. You can also try rubbing the block with paper and fabric transfer crayons. Then flood the design with transfer paints and iron the result onto fabric.

The stitching methods described previously would all work well for block-printed designs. Other options for stitching could be to stitch nappy (diaper) liners over the print, using an open, built-in machine pattern. Free-machining could also be used, as long as the stitching is not too dense. After stitching, rub with a Markal (Shiva) oilstick and then 'zap' with a heat gun. The liner will shrink and cling around the stitching, revealing the pattern (see figure 94).

Pin tucks add an attractive surface texture to a block-printed fabric. This might be suitable for a detail on a garment, or to make a cushion. Pleats could be used, either marked and folded, or using a pleatmaker. Scraps of fabric, cords or braids could peep out from the pleats. Shapes could be cut from the printed fabric and applied to a new background fabric.

Slivers of silk tops or silk waste could be placed on the block print, with a layer of net holding them down. Free-machining or massed automatic patterns could be used to hold the layers together and add further texture.

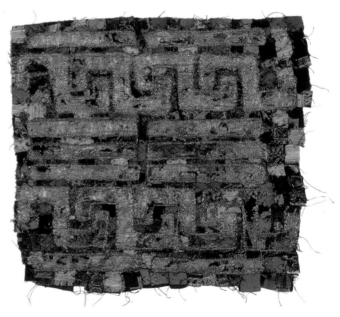

Figure 94 *A painted nappy (diaper) liner was laid over the top of a fabric made from masses of tiny pieces of fabrics. A key pattern was stencilled on the nappy liner in gold and outlined with free running. A heat gun partially burnt some of it away to reveal the background.*

Figure 95 *A grid of stitching which could be used on water-soluble fabric, first across the shape and then along it, to hold all the stitches together.*

Other stitching methods

Look at the designs that can be produced by the drawing methods suggested at the beginning of this chapter. Some of them may suggest a certain fabric or technique. Any of the following methods could be used for stitching your designs.

Using outline drawings

An outline drawing filled with a linear design may well be suitable for stitching on water-soluble fabric. The heavier lines around the edge could be satin-stitched, with the inner patterns in free running stitch or whip stitch. Remember to stitch over each line several times to stop unravelling during the washing-out process.

This same design could be transferred to a painted or decorated fabric by tracing it onto tissue paper. Place this on the wrong side of the work – remember that the bobbin thread will be the one to show on the top. Now free-machine over all the main design lines. Take the fabric out of the machine and tear away the tissue paper. Turn right side up and complete the stitching using threads that complement the existing stitching.

Figure 96 *A spiral border was drawn and then scanned into a sewing-machine software program and digitized. It was stitched on a variety of backgrounds, including water-soluble fabric, net and felt. The felt one was distressed using a soldering iron.*

ChromaCoal

Enhance the block-printed designs using ChromaCoal sticks. These are like chalky pastels that can be heat-set to fix the colour on fabric. If used to draw over the block-printed lines, they will add a particular vibrancy which could be built up by hand or machine stitching. They can be smudged in the same way as ordinary pastels, and give a very attractive effect when merged in this way. Use an iron or heat tool on the back of the fabric to set the colour. Further layers can be built up, setting each layer as you go. They are also very effective used over heavy stitching.

Figure 97 *Design taken from a Celtic mirror. Sheer fabrics applied using satin stitch to black felt and zapped with a heat tool. A woodburning tool is used to make marks similar to those on the original.*

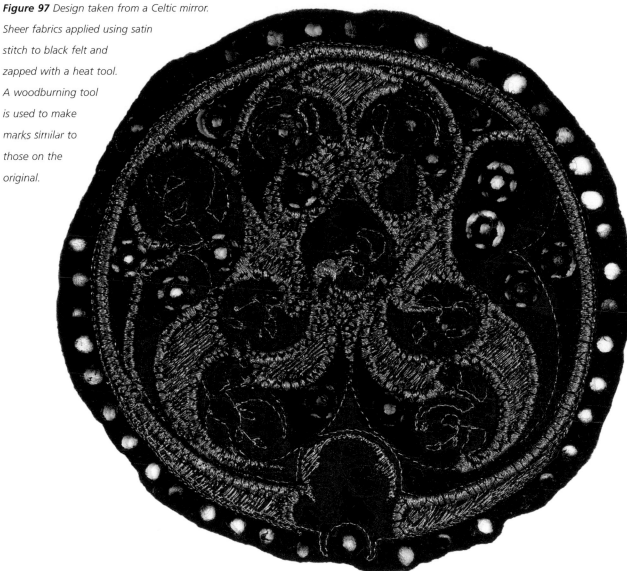

Silk papers or felts

Stitch one of the designs onto silk paper. You can buy this ready-made, or make your own using teased-out silk tops and a suitable adhesive. It's probably best to use the tissue-paper method for transferring the design. If you find it difficult to stitch on the silk paper, back it with Stitch 'n' Tear and pull it away from the work afterwards. Further stitching can be done on smaller pieces of the fabric and applied over the top to add greater texture. See figure 99 overleaf on page 72.

Figure 98 *A continuous line forming spirals. This can translate into machine embroidery or hand stitching such as couching or line stitches.*

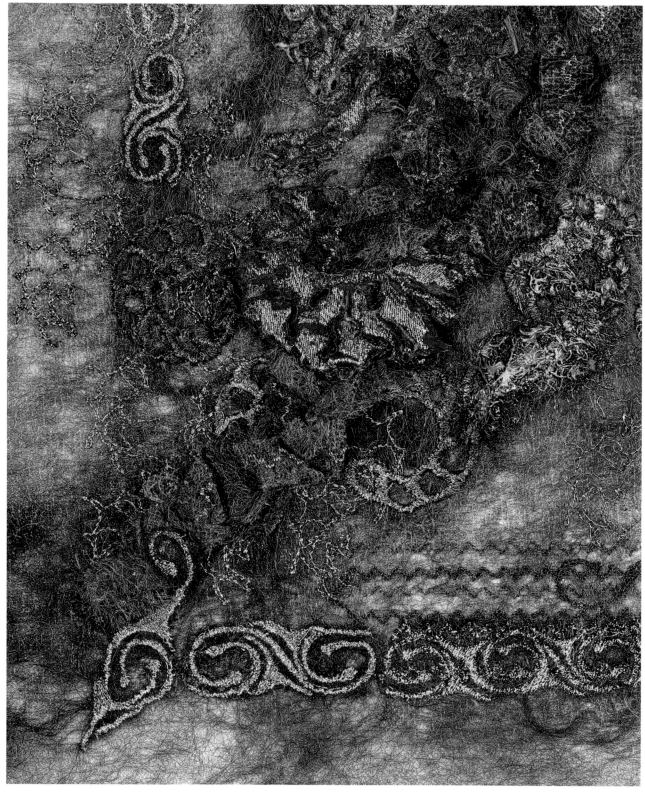

Figure 99 *Spiral designs stitched on silk paper to form a border.*

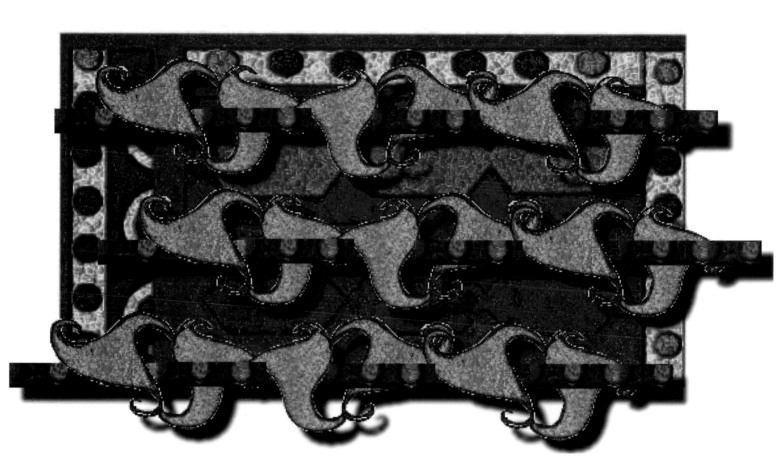

Figure 100 *A computer design based on trisceles, which gives the effect of layers of stitchery.*

Applying fabrics

When using appliqué techniques, take care when applying the fabric. All-over stitching helps considerably to bed-in the applied piece. For instance, a continuous line of spirals could be stitched over the top. Do this using free running stitch, doubling back on each spiral as you stitch it so that you don't have to keep lifting the needle from the fabric (see figure 98 on page 71).

Adding a sheer fabric that can be 'zapped' with a heat gun after stitching gives texture and interest. Consider adding previously stitched applied fabrics to a background. For instance, a block-printed or stencilled background design of spirals could have further stitched spirals added, making them smaller or larger to vary the scale. These applied pieces can be stitched

on net or on painted vanishing muslin, and partly burnt away to leave lovely frayed edges. This method can also be used to apply strips of stitching over previously stitched areas.

Felt works particularly well when it is heavily stitched, as strips can be cut close to the edge and applied. Spirals stitched in this way look very good applied to a background. Figure 101 (overleaf) uses a design based on trisceles and shows strips of trisceles stitched on felt and cut out, with a further strip of stitching threaded through them. This works on any design that has gaps suitable for threading through, and produces raised effects that add interest to flat surfaces. The design for this piece is shown in figure 100.

Figure 101 *Three flags were made using the design in figure 100 as a guide. They were heavily stitched and further cut-out strips of stitching were then applied. When complete, the flags were mounted on photograph holders and the bottoms of these were painted and gilded.*

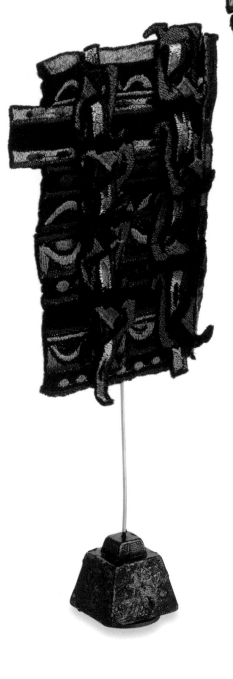

Metals and meshes

Metal shims and meshes can look very good as cut-out spiral shapes. The metal must be thin, gauge .002, or you will not be able to stitch into it. Some metals can be heated to change their colour before they are stitched. Hold the metal in a flame, being careful to hold the tongs with an oven glove or similar. The shape can be cut out freehand, or a stamp could be used on the reverse of the metal to give cutting lines. To attach the piece of metal to the background, either pierce holes in the edges of it or use the sewing machine to stitch into it, taking care to blend the edge of the metal into the fabric. If using the sewing machine, be sure to back the piece with heavyweight Vilene to avoid snagging the thread.

A range of excellent effects can also be obtained with the embossing powders sold in rubber-stamp shops. These can be painted onto the metal with inks or paints (so long as the paints can be safely heated) and then a heat tool can be used to puff up the powder. Rubber stamps can also be used in this way.

Wiremesh is another metal product. A little more subtle than the shim, it is a very fine mesh that is easy to stitch into, and combines well with stitching to give a lovely shimmer to a piece of work. It will change colour when heated and reacts with the embossing powders in the same way as the shim. Nail varnish is a good way to colour the mesh, especially given the range of colours now available. Cut spiral shapes and stitch them into the background as before. The mesh is useful to add accents (perhaps in linear strips as shown below in figure 102) or small spot motifs stitched well into the background.

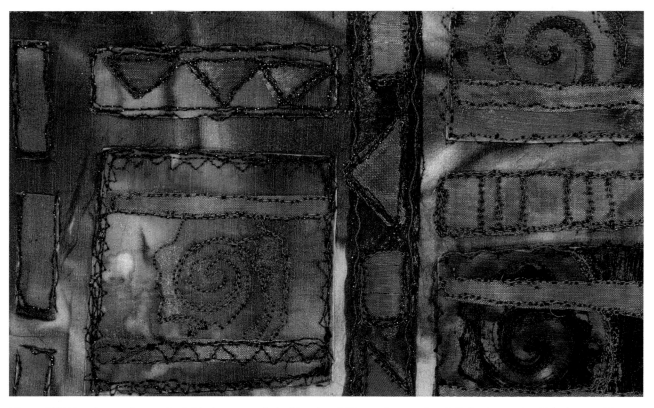

Figure 102 *Prints from a thermoplastic block were applied with strips of Wiremesh to a painted silk background. A little free machine embroidery was used to highlight the designs and blend the Wiremesh into the background.*

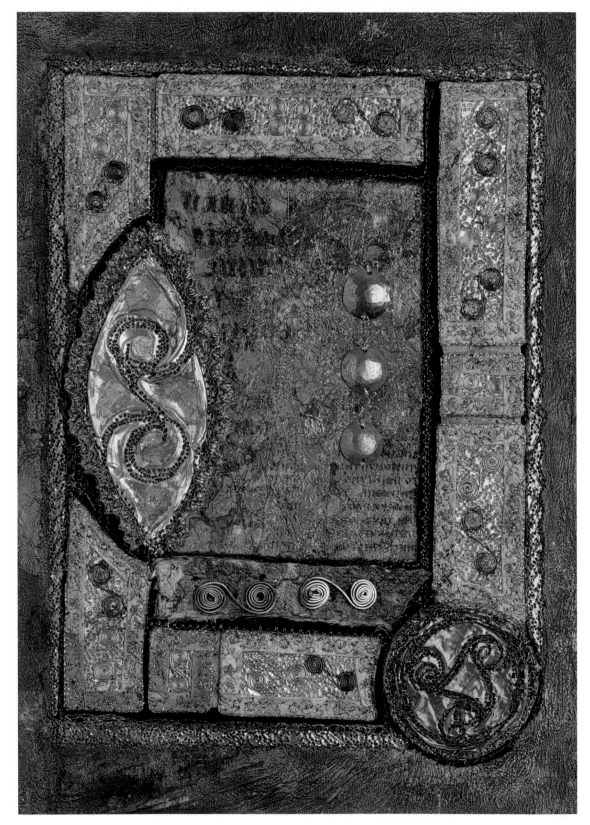

Figure 103 This is a finished piece based on the Lindisfarne gospels. The pieces are made separately and applied to the background. Stitched metal shim and coiled wire spirals are also used.

Florists' wire is very suitable for adding accents to embroidery, and the spiral shape is easy to make. Cut off a suitable length of wire – about 25cm (10in) is a good average length. Using pointed pliers, grab the wire as close to one end as possible and fold it over itself to make a loop. Adjust the loop so that it is as small as you can make it. Then, with the pliers across the loop, and holding it firmly, begin to wind the wire around it. If you want a tight spiral, wind slowly, a fraction of a millimetre at a time. It will build up surprisingly quickly.

There are many weights and thicknesses of wire to be found at specialist shops, but ordinary craft shops and garden centres can be useful too. Florists' wire is cheap, comes in many lovely colours and is ideal for coiled-wire techniques. Thick garden wire is usually green but it takes a metallic spray very well. This is good for heavier pieces. Look out for wire napkin rings and candle holders in the houseware department. These can serve as a base with fabric placed behind, or woven through them.

Fine wire can be threaded with beads before being bent into place. This is very effective when added to embroidery, as the beads give emphasis to the thinner wires. The whole piece can then be stitched into place. It is best to do this by hand.

Shrink plastic

This is an unappealing material at first glance, looking just like a sheet of overhead-projector film. However, with the right treatment, it can be developed into a variety of decorative additions for your embroidery. The plastic can be coloured and will shrink with heat, which will brighten the colours and intensify the design. The plastic will need to be rubbed down to give it a surface that will take colour. Use fine emery paper and always try to rub in one direction to avoid a scribbled look.

Here's how to make small tiles to apply to a stitched background. Using a spiral design that measures about 7.5cm (3in) square, place the plastic over the design (having rubbed down the plastic) and use ordinary coloured pencils to transfer the design onto it. Colour it all over – don't leave any gaps. It will look quite pale and washed out at this stage but will be fine when it has shrunk. Now draw over the outlines with a gold felt-tip pen. Go all around the edges of the tile. This may seem odd because it is so thin, but it will become thick when heated, and will look like plastic if this step is not taken. Allow to dry and then use a hole punch to make holes in the corners. Overleaf is a trick to get the holes in the right place.

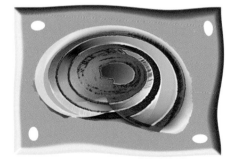

Figure 104 *A diagram of a design printed onto shrink plastic, and the change of size and distortion that results from the heating.*

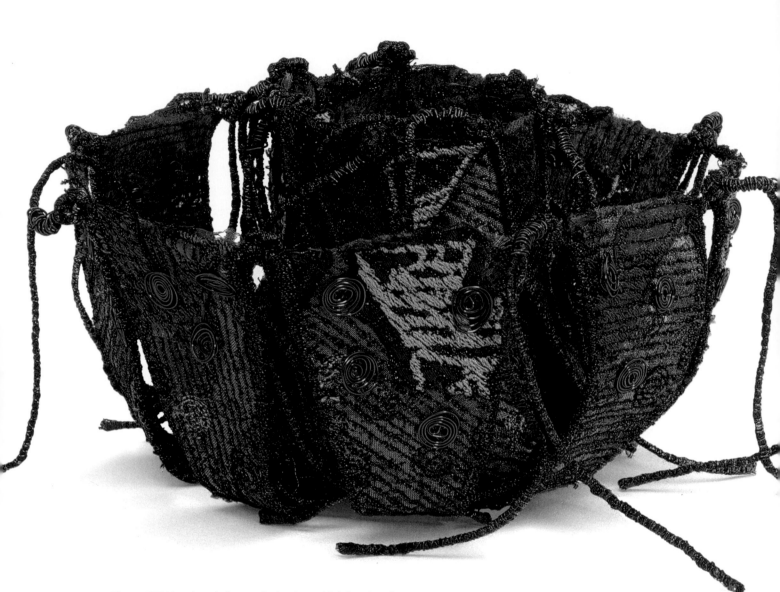

Figure 105 *Vessel made from a single piece of fabric, printed with spirals and firmly stitched. Pieces of stitching and coiled metal wire were applied on top.*

■ Take the bottom off the hole punch and work with it upside down. Mark the plastic where the holes are to go and slide it into the hole punch until you can see the mark. Turn the hole punch the right way up and press. (This is important in order to protect your eyes from flying plastic.) The holes will look very big, but they will shrink.

■ Now place in an oven at the temperature shown on the packaging, or use a heat tool to apply heat to the plastic. It will curl up alarmingly but will flatten before the end of heating. The result should be a delightful tile to apply to a background.

■ Make three more tiles, reversing the design if necessary to form a block.

The tiles can be used as central areas or on borders, but care must be taken in placing them. They are best nestled into a fabric such as velvet, where they can be bedded into the fabric.

Cut-outs work well, too. Try cutting out spiral shapes, remembering to include the gold around the edges and the holes for attaching them to the fabric.

Another way to colour the plastic could be with Pebeo gel. This is a jelly-like glass-painting medium that can safely be heated. This can be allowed to dry and then stamped with a rubber stamp before heating.

It is also possible to use stampers' embossing powder after heating.

Of course, you don't have to stick to tiles, beads and so on, as the shrink plastic can also be a very suitable material for jewellery. Beads can be stitched into the surface before it is heated. If you want to attach beads, either make a hole with a strong needle for a beading needle to pass through, or use beads that will thread onto a fairly strong needle. Make sure that the thread used will withstand the heat. Metallic threads are usually fine for this.

Figure 106 *Shrink plastic has been coated with Pebeo gel and a spiral design has been drawn onto each tile. The tiles are then applied to a textured background.*

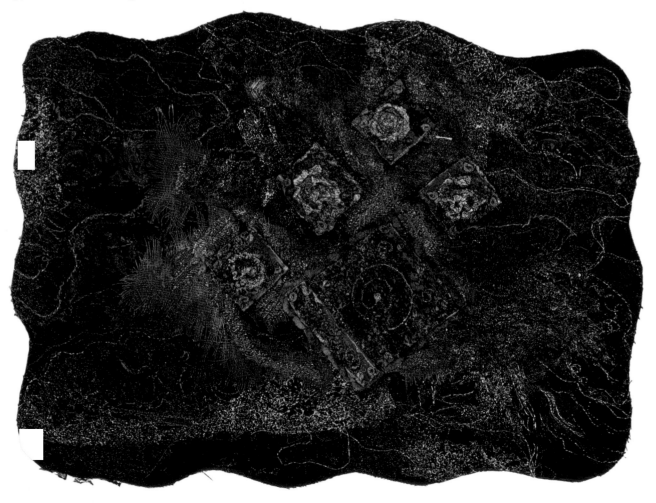

Lettering and manuscripts

The highly decorated manuscripts of the Celts are among our most treasured possessions. The richly jewelled shrines and caskets in which they were kept are a measure of their worth. In fact, many of these illuminated manuscripts are Anglo-Saxon rather than Celtic, due to the merging of the cultures that occurred through the conversion of the north Northumbrians by Irish missionaries sent out from the island of Iona in Scotland. For our purposes, we shall include them as part of our Celtic inspiration.

Many of the gospels have the most intricate designs – whole pages of wonderful colour and pattern interspersed among the text pages that convey the gospel message. The Book of Kells, now housed in Trinity College, Dublin, is one of the best known. The opening page of each gospel shows an intricate initial letter that takes up the entire page in a breathtakingly complex arrangement of borders, roundels, stylized animals and intricate interlacings.

Other pages show more symmetrical designs. These are known as 'carpet pages' and were used to divide the gospels from each other. The Book of Durrow has lovely examples of these.

All monasteries needed copies of the Bible, the psalters (books of psalms) and missals (service books) for the conduct of divine offices, but not all were capable of producing them. Major works like the Book of Kells or the Lindisfarne Gospels would have needed a large establishment to supply the necessary skills. The monks were Benedictines, following the Rule of St Benedict with regard to the times of offices, meals, manual work and producing these manuscripts. Living conditions for monks at this time were harsh. Many of the books produced went to other monasteries, but relatively few would have been as richly illustrated as these two works.

It is believed that specialist monks illustrated the manuscripts, leaving the pure copying to those who were less skilled. Copying was a relatively simple skill and involved the monks transcribing in Latin. Few of them would have understood that language, so as a result there were frequent errors (and somewhat less frequent corrections). Not many of the monks produced original work.

In many of the abbey scriptoriums (writing or copying rooms) there were scribes who specialized in certain elements of the page. Some dealt with the lettering, some with the zoomorphic animals, and others worked on the pure design of the carpet pages, thus allowing specific talents to blossom. There also seems to have been a cross-fertilization of ideas between the scribes of different monasteries, with new ideas and styles flowing between them. This suggests that the monks travelled to other monasteries, exchanging motifs and designs. Coupled with the 'hand-me-downs' from earlier ages, this would explain the existence of identical motifs and letter forms in manuscripts of different ages and locations.

The pages were generally made of vellum (calfskin) because it is strong and durable. The skins of young calves were most prized. These were soaked in lime or urine to remove the coarse hairs and then scraped, stretched and dried. In early medieval times, the economy was based on cattle, so there would have been no shortage of calfskins.

Before work could begin, a page was ruled with a pointed instrument to provide lines on which the monks would write. The pens they used were generally taken from the tail feathers of swans or geese. Scrapers – often blunt knives – were used to make erasures for corrections. Pages used solely or primarily for illustration were ruled specially by the artist monks, using compasses, rulers, French curves and templates. These artist monks would then take the pages already written (or previously ruled) and begin the work of illumination. Brushes were widely used.

Most of the inks used were made from crushed oak apples, with chemical additions, and mixed with gum and water. Where a particularly black ink was required, it was made from lamp soot. Cow horns were generally used for inkwells. Colours were made from chemical dyes – orange from red lead, green from verdigris (although this was used sparingly because of its tendency to eat through the vellum), blue from woad or indigo, red from vermilion and, occasionally, a particularly rich blue from lapis lazuli. Many of these components had to be imported, suggesting extensive trading links (lapis lazuli, for example, had its source in Afghanistan). Some of the chemical processes used in producing these colours were quite dangerous.

Completed manuscripts were bound, usually in leather. When not in use, these books were stored in highly decorated cases, known as shrines, which were often made of metal.

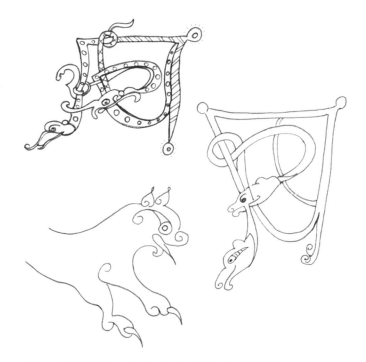

Figure 107 *Sketches of animals intertwined with initial letters from the Book of Kells.*

Figure 108 *Computer print bonded to felt with a stitched initial applied. The background has been stitched with a built-in pattern.*

Types of lettering

Early examples of lettering, such as those in the Cathach of St Columba, a book of psalms, are curving and shapely. Red dots can often be seen around the outlines of these letters, adding a pleasing hint of colour. (These should not be confused with the red dots that indicated errors.) Many of the letters, particularly the capitals, were decorated by the addition of motifs in the spaces between the uprights of the letter. Further ornamentation was added to the ends of the uprights in the form of scrolls or spirals.

Individual letters came to be filled and decorated with a riot of motifs, spirals, interlacings and animals, all fitted in with a pleasing harmony. The shapes of the letters became more abstract too, allowing for ever more decorative fillings. Many of the design elements can be linked to the contemporary metalwork designs, also with intricate spirals, roundels and interlacings. The colours used in the manuscripts could have been based on the deep golds and bright enamels used in the brooches, chalices and shrines of the time.

The Book of Kells is probably the manuscript that most people associate with Celtic-style lettering, and no trip to Dublin can be complete without a visit to Trinity College, where it is housed. The alphabet used features zoomorphic designs, with many of the animals having delightful expressions and performing incredible contortions. Birds, snakes and lions writhe around the letters, interlacings and leaf motifs.

In addition to the rounded script, a more angular letter form can be seen. This can be found in the Lichfield Gospel Book and the Lindisfarne Gospels although it also appears in the Book of Kells.

It can readily be seen how these wonderful designs can inspire embroiderers, although the difficulty here is, as we have said before, how to take the perfection of the designs and turn them into textiles. The answer, of course, is to be inspired by the colour and shape or the overall impression, or to take details of the letter, and use some of these aspects in stitch, rather than trying to create a recycled Book of Kells.

Figure 109 *Parts of letters used to make patterns, drawn with black ink. They were coloured by dabbing teabags over them, and then Button Polish (a type of furniture polish) was added. One was enhanced with coloured pencil.*

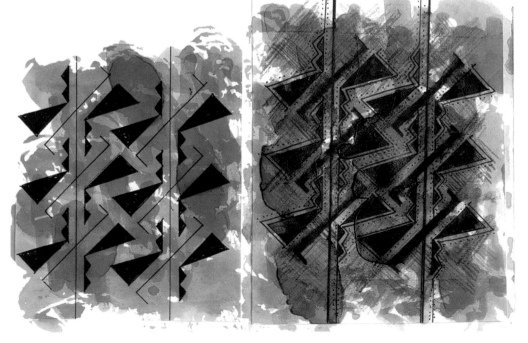

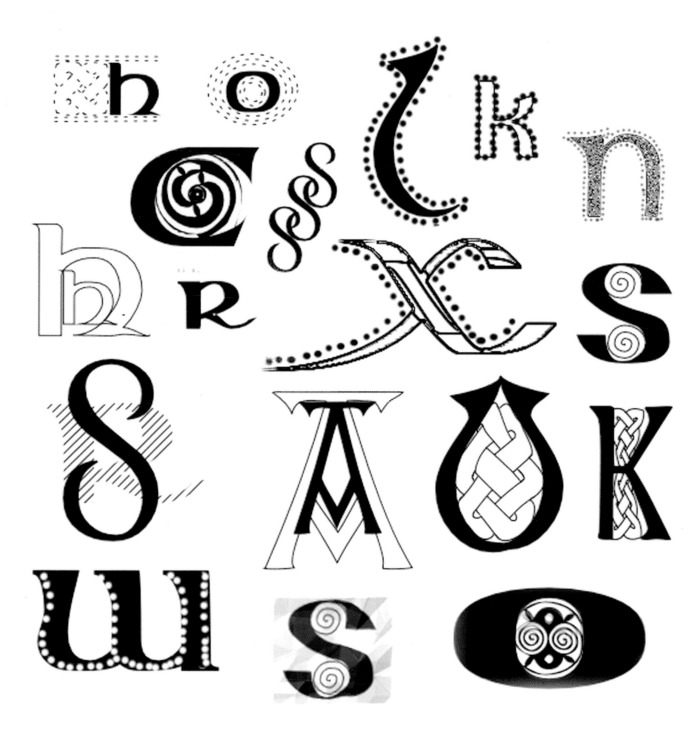

Figure 110 *Some Celtic-style letters and ways of decorating them.*

Design

It is relatively easy to find sources for Celtic-style letters. Dover books, which allow copyright-free reproduction for craft workers, can be found for both the ornate letters and the plainer script. There are stencil books, and even children's colouring books, which provide clear outline drawings. People with computers can obtain fonts in many styles of Celtic lettering, and these can be used in a word processor, so it isn't even necessary to use a paint or draw program. CDs of suitable clipart can be found and many of these are very good.

Using a photocopier for design

■ Photocopy a copyright-free image, clipart or one of your drawings. Cut out the copy and make a repeat pattern. Set the photocopier to Invert to obtain a white-on-black design.

■ Cut this into strips and weave both copies together. Weave through one section only of the design so that it does not become too complicated.

■ Take a small area from this and enlarge on the photocopier. Trace the design, smoothing the curves to eliminate any rough edges.

■ Photocopy again onto acetate sheets. Most photocopy shops stock acetate. Lay the sheets over a coloured background – perhaps one of your previously painted or block-printed papers.

■ Photocopy the results of this, which should give you some interesting grey tones. Make several photocopies, experimenting with the Invert option. Paint the photocopies using acrylics or inks. You could also use fabric transfer paint to transfer the design to fabric.

Figure 111 *A letter S from a Celtic computer font was printed in black on white and then inverted.*

Figure 112 *The two designs were cut into strips and woven together.*

General design

For general design, try making backgrounds using some of the processes described in earlier chapters. Pressprint (see page 68) or string blocks (see page 47) could be printed onto paper. The designs should not be too overpowering (an all-over design of spirals or plaits would work well), and should not contain too many colours in the printing. Tea or coffee could be used over the top of the design to tone down the colours. Xpandaprint (Puff Paint) could be applied on top of these backgrounds, either through a stencil made from a copyright-free book design or from freely drawn lettering motifs (see page 29 for advice on making your own stencils). After you have heated it, the Xpandaprint (Puff Paint) could be painted or waxed, maybe with a metallic wax.

Computer design

With a paint or draw program, a scan can be taken direct from the reference material, drawings, stencils or Dover books. There is also an excellent CD-ROM of Dover designs that could be used to import designs directly into software. These letters can be put through filters to distort them.

Figure 116 (overleaf) shows a block that was printed on corrugated card with gold paint. This was used as inspiration for a series of experiments using paint and paper. The following options were explored, among a great many others.

- A wooden block was printed on corrugated paper and covered with tissue paper and more paint applied. An X from the computer design was then stitched on net and applied to the background.

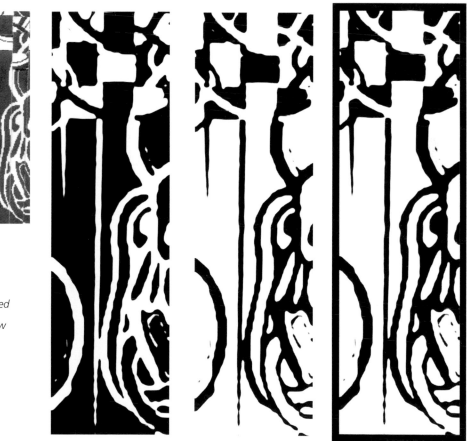

Figure 113 *A small part was isolated and greatly enlarged to make a new design.*

Figure 114 (right)
Coloured versions
using the design
from figure 64 as a
background.

Figure 115 (below)
The original letter
was pasted over
one of the
backgrounds and
different
colourways tried,
using shaded
colours.

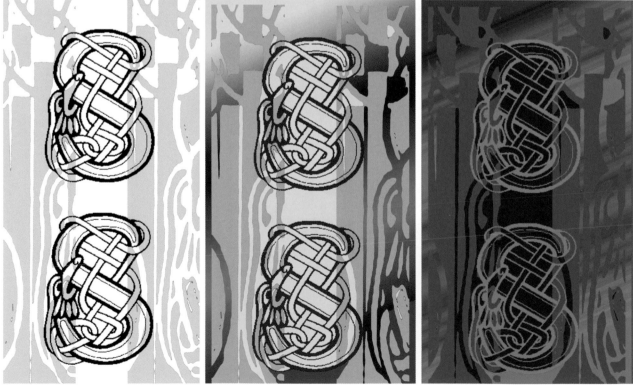

Figure 116 *Three samples using the letter X. The backgrounds (left to right) are corrugated paper with painted and torn tissue paper; painted and pin-tucked fabric; and paper beads glued to brown paper with painted, torn tissue paper.*

- A computer design, printed on brown paper, had the edges burnt. Paper beads were then made from further printouts and glued to the background. Painted tissue paper was added and a further large X stitched on net was applied over this.
- Shibori dyed fabric was stitched to felt with a twin needle. The same fabric was then stitched with the X shape and applied on top. Painted kebab sticks were used when the second piece was applied, to raise it and add interest. A further X, stitched on felt, was poked beneath the sticks on either side.
- A computer printout was pasted with kebab sticks. Tissue paper and print were glued over this and distressed while wet. Parts of the letter X, stitched on net, were placed on top.

Some of these samples were selected to be scanned into the computer and used to form the final design. A background was made and put through various special effects. Lines of lettering were typed onto it using a Celtic-style font, and the original sample shown was used as the main initial letter. This design is shown on page 88.

Paper beads could be made from some of the computer printouts. These beads could be made on a large scale, by rolling triangular strips of printout around a kebab stick and sticking down the end. They could be used as dangly decorations, in a book spine, or built up on wires over a background.

Figure 117 A design for a panel based on an initial page which could be carried out using Perspex rods as the base, printed and painted transparent fabrics, and applied stitched letters.

Design to stitch

The computer was also used to produce the materials for a series of pieces based on manuscript pages (figures 118–120). For these, one of the Celtic fonts was used to cover the whole screen with type in various sizes. This was printed on tissue paper by pasting the tissue firmly around the edges to a piece of printer paper. Cut the tissue slightly larger than the 'carrier' paper, so that it can be trimmed after pasting. Make sure that it is stuck firmly and then print the letters, ensuring that the tissue side is printed. Cut them away from the carrier paper and

discard that. Now iron Bondaweb (fusible webbing) onto a piece of thick Vilene interfacing, and peel the backing paper from the fusible webbing. Then press the printed tissue, print side up, onto the warm webbing, crinkling the tissue while placing it on the surface to encourage texture. Iron again, using baking parchment (silicone paper) to make sure that it is firmly stuck down. Finally, use tea or coffee to stain the fabric and achieve the look of an ancient, distressed piece of printed vellum.

A variation of this method is to use felt instead of Vilene, which gives a softer, more leathery feel.

Those without access to a computer could use a stamp with lettering to achieve the printed look. However, at the tea/coffee stage this may run, if non-waterproof ink is used (this could be interesting!).

A spray available from rubber-stamp supply shops, known as 'webbing spray', can be used at this stage. It is available in a variety of colours, the best being gold or black. We find that black is best on this manuscript-like fabric. Cover a wide area with newspaper when spraying, and spray from a height of about 60cm (2 feet) above the work.

Further ideas for lettered backgrounds

The resulting fabric can be distressed further by using tea- or coffee-soaked nappy (diaper) liners over the fabric. Tear into strips and free-machine or use random machine patterns to apply them to the background. Rub with a little Markal (Shiva) oilstick or metallic wax, and 'zap' with a heat gun. The effect that the liners achieve depends very much on the density of the stitching – they cling more to heavily stitched areas.

Use hand or machine stitching to add detail to the background fabric. This should not be too overpowering if you are planning to add motifs on top.

Try applying gold encaustic wax (a beeswax product) lightly over the background. Do this by heating the background with an iron or heat gun and rubbing it with

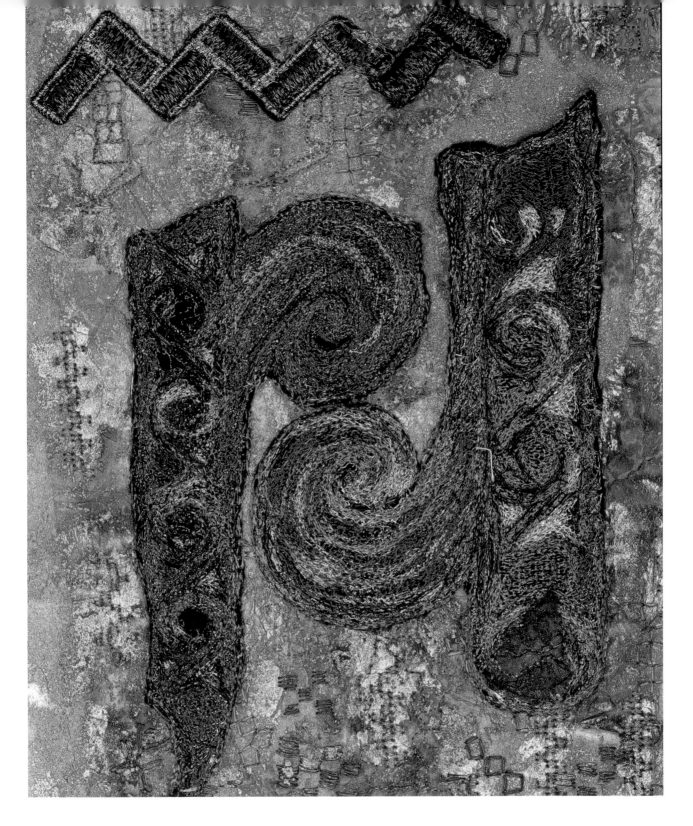

the block of gold wax. Alternatively, acrylic wax could be used with a little bronze (gold) powder added. (Note: It is important to wear a mask while mixing.) This could be applied all over or just in certain areas. It can look very interesting applied over the stitching.

Figure 118 *Design based on a lower case 'n' from the Lindisfarne Gospels. A heavily machined piece is stitched on felt, cut out and applied to a tissue and felt background. This background has been stitched by hand and machine.*

Figure 119 Based on an illuminated letter, this piece has a background of tissue paper bonded to felt. The letter was free-machined onto felt, cut out and applied. The border design was transferred to felt using the tracing paper method and was then machined using free running stitch before being cut out and applied as before.

Embellishing the background

Now you have made and stitched the background, it can be embellished in a number of ways, always bearing in mind the need to consider line, form and contrast. Referring to the design or working drawing, consider the following.

- Work heavy machine embroidery on felt (black felt gives dark outlines that help add contrast). Cut out the shapes and apply these to the background with further free machine stitching. This will cause the stitching to distort slightly, giving a quilted effect. The design could be done on the computer, printed on tissue paper and transferred to the felt by the free machine outline method.

- Use the automatic patterns on the machine to simulate floral scrolls, which appear on motifs in many of the Gospels. Motifs could be stitched on the same fabric as the background, and darker stitching could be used to introduce contrast when

applying the motif. You could also draw into the background or paint with drawing inks, to give darker edges and add definition.

- Refer back to the use of metal on page 75. Fine metal shim can be useful in conveying the golden glints of the illuminated manuscripts. Be careful, however, not to have large areas of metal, as these can be too shiny and upset the balance of the work. Use stitch, patination fluid or embossing powder, as previously described, to knock back the shine. Small areas, such as roundels, work well when included in an overall design. Lazertran is a special paper used with colour photocopiers to transfer designs to metal. This process is described in detail in our previous book, *Layers of Stitch*. Wiremesh with a Lazertran pattern on it can look fabulous when stitched well into the background. Use the same lettering design that was used for the tissue.

■ Look back to the border designs shown in figure 103 on page 76. Try some designs based on these patterns. These could be made from strips of heavy Vilene with metal shim stitched over them. A variegated thread gives a good effect. Make long strips, then cut them into smaller pieces (observe the shapes in the borders), and add edges made from long thin strips of tea- or coffee-soaked Vilene. Cut this to size in a log-cabin arrangement around the edges of the borders and apply to the metal using a pattern from the sewing machine. You can add wire scrolls or spirals and finish the edges with paint or hand stitching. Arrange to match your design or drawing and machine to the background, avoiding the wire when you stitch.

■ An alternative background can be made using a computer design and printing it onto T-shirt transfer paper (which can easily be found in computer shops or stationers). Before you iron the transfer paper onto fabric, scratch away some of the design using the flat blade of a knife. This gives a wonderfully distressed surface that is ready for further embellishment. A dab of tea or coffee over the transferred design can also help with this 'aged' look.

■ Add papers or fabrics over the top of the background and slash the fabric to allow the background to show through. You could stitch on top of the paper or fabric, and slash or burn in a pattern sympathetic to the stitching.

Figure 120 *A variety of samples showing computer prints bonded to felt and craft Vilene, and stitched metal shim with light initial stitching. This photo also shows Wireform with a Lazertran image, ready to be stitched.*

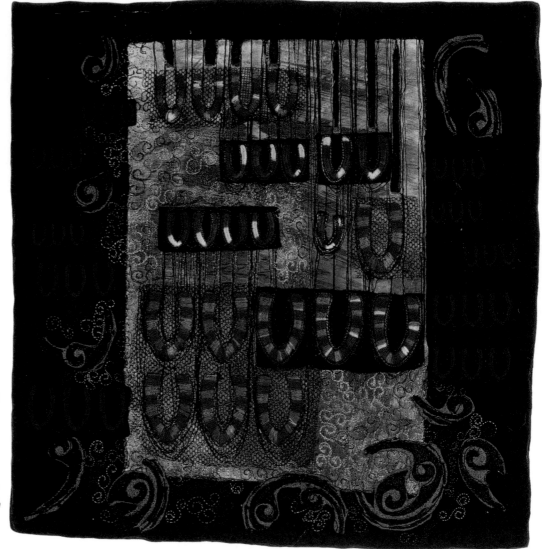

Figure 121 *A panel built up using repeated letter 'V's, on fabric printed with transfer paints, and areas filled with stitched scrolls.*

Cut-out letters

If your sewing machine has an embroidery unit, you will be able to stitch large letters on felt and cut them out. If you don't have this option, you could draw or stencil the letters onto tissue paper, free-machine around the outline of the letters and then, when the tissue has been pulled away, fill with free machine stitching. Decide whether you want to use the same letter, varying the size, or a variety of letters. When you have enough letters cut out and ready to stitch, here are some ideas for using them.

■ Place the letters on a background, perhaps one made using some of the techniques described earlier. It is best to work to a design and to consider ways of applying the letters. You can use lines of stitching to integrate the letters with the background.

■ In figure 121, the letters are printed in several sizes and placed on strips of fabric in the background. Additional stitching over the top integrates all this into the background. Further motifs stitched on felt have been applied around the edges as a border.

■ Cut-out letters can be added as a border, either actually forming the border, or integrating them with other stitching. Another way to make a border is to thread wrapped cords or cut-out bands of built-in patterns through letters such as O or S.

■ Consider making vessels and shallow bowls covered with large letters. Wireform, a 'stitchable' wire mesh, can be used as a base and the cut-out letters can be stitched onto it. A sheer fabric could be laid over the Wireform first. Alternatively, a commercial vessel with a firm wire frame could be used as a base. In the example shown in figure 123 overleaf, paper beads made from computer printouts were wired to the frame. Cable patterns were stitched onto red and turquoise felt, which was cut out and wound among the beads. Large Celtic letters were then stitched in red metallic thread onto turquoise felt. Whip stitch was worked round the letters and, finally, the letters were stitched onto the frame.

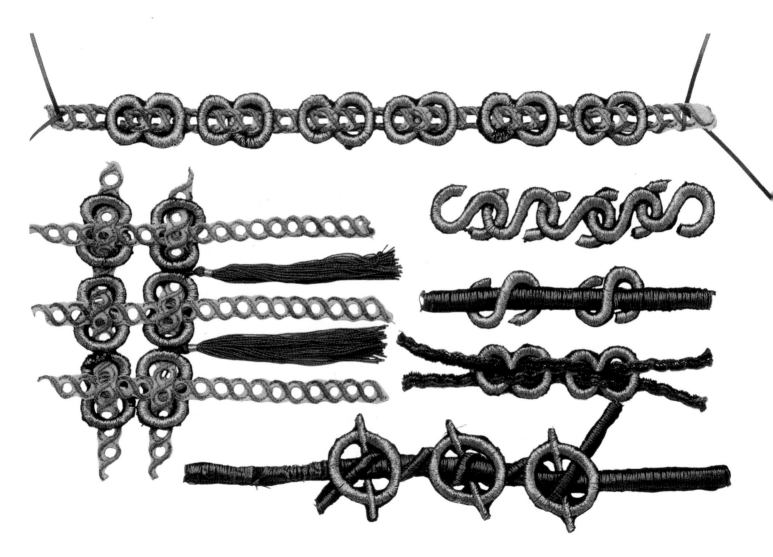

Figure 122 *Large stitched letters used to make braids.*

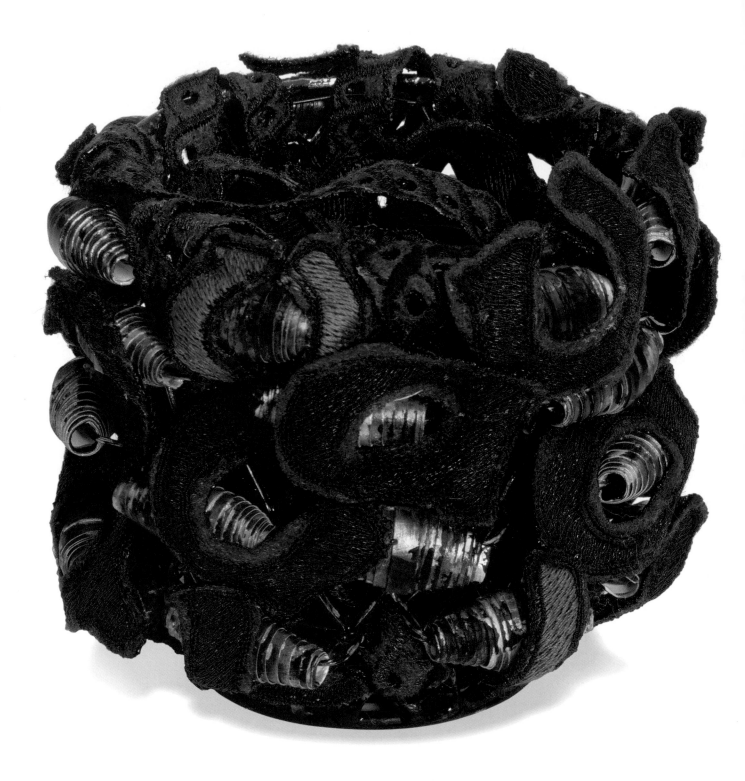

Figure 123 *Letters and strips of cable pattern were woven through a wire base with painted paper beads wired onto it.*

Using built-in lettering

Many sewing machines have small lettering patterns among the built-in, or ribbon, stitches. These can produce good results, but you may need to experiment to find the best settings and stitch types. Lines of lettering can be most effective, especially if they are divided by rows of straight stitch. Straight stitch works much better than pattern here. Using a fabric decorated in this way as a background, stitch large letters over the top. Use a Celtic font and the tissue-paper transfer method. When the outline design has been transferred, stitch around it using a narrow satin stitch or even fill the shape with machine embroidery. Then place it on felt (or wadding, with a firm base fabric) and free-machine around the large letters to quilt them. An alternative to this could be to stitch heavily, using built-in patterns or letters, all over a prepared decorated fabric. Then cut large Celtic letters from this fabric and apply them to a suitable background, stitching them in place with free machine stitching.

Try stitching lines of letters, again divided by bands of straight stitch, so that they overlap and build up into an overall pattern. Try this on black fabric with a variegated thread. It looks great.

Large letters stitched on pale, synthetic fabric with synthetic thread could have previously painted transfer papers ironed over them. The stitching and the background fabric take up the paint in different ways and this can be a most effective way of colouring fabric. Try a variety of fabrics and threads – metallic threads work particularly well.

Figure 124 *Lines of words, overlapping each other to blend the colours.*

Figure 125 *Distorted words were scanned on a computer and stitched onto black felt.*

Figure 126 The same stitching was worked on white and coloured fabrics and coloured afterwards with transfer paints.

Layers of words

The following technique brings together many of the lettering processes. See figure 128 overleaf.

A Use acrylic felt as a background fabric. Tease out trilobal nylon and spread a thin layer over the felt.

B Place a nappy (diaper) liner on top.

C Stitch rows of letters, words or a narrow pattern, not too close together. Colour the liner with

ChromaCoal sticks and Markal (Shiva) oilsticks. Allow to stand for 48 hours.

D Stencil much larger letters all over the top in a random fashion, using metallic paints. Allow to dry. Stitch around each letter using straight-stitch free machining. Melt with a heat gun. This will melt the liner and some of the nylon tops.

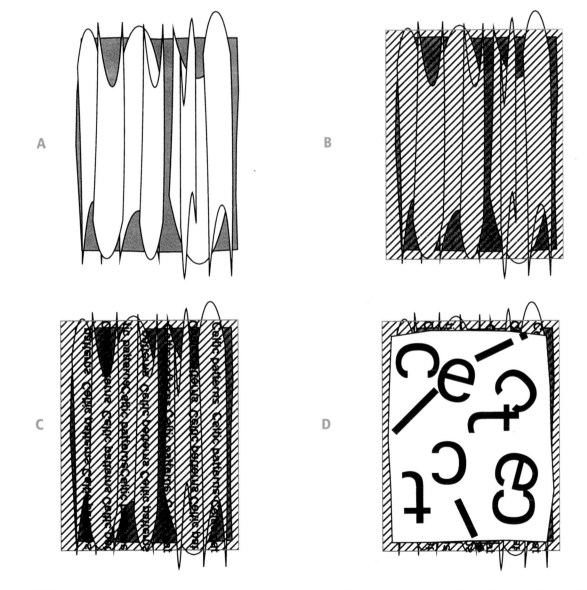

Figure 127 *Using nylon tops – these are first teased onto a background fabric, then a nappy (diaper) liner is laid over them, with added stitching and melting to give texture and blend the surface.*

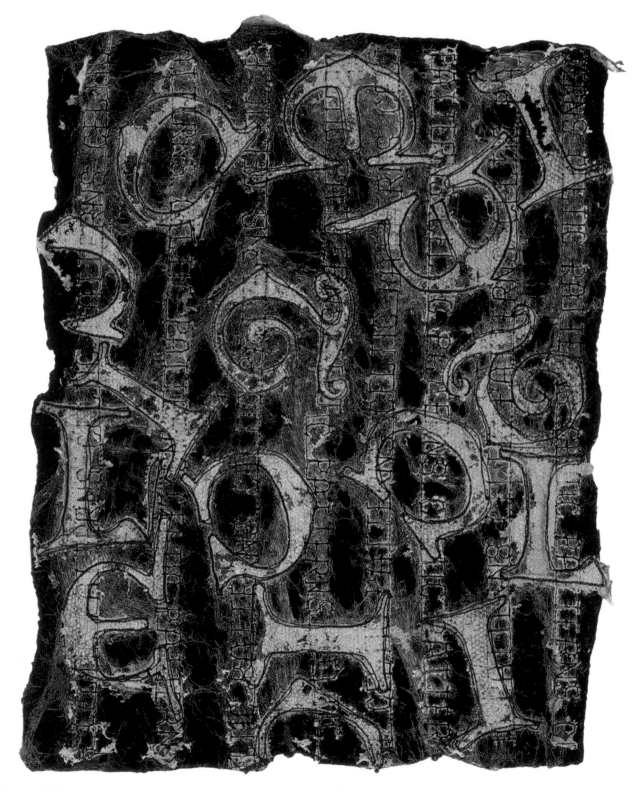

Figure 128 *Trilobal nylon was laid all over a fabric and a piece of nappy (diaper) liner placed on top. Large gold letters were stencilled and then outlined with red stitching. Lines of words were stitched, and then a heat gun was used to melt and blend the surface.*

Flower stitcher

Many of the Celtic manuscripts use dots around the letters and also make full use of circle shapes and roundels. We have used some artistic licence and interpreted these circles using the flower stitcher, an attachment available for most sewing machines (check that yours will fit before investing in one). This stitches perfect circles, which vary considerably according to the stitch used. Open patterns are quite flower-like, while satin stitch (close zigzag) gives more solid 'doughnuts'.

The flower stitcher can be used to produce backgrounds for cut-out letters or can be used to stitch over the top of the lines of ribbon letters. The nylon tops and nappy (diaper) liner technique works very well with flower-stitched patterns. Here, again, large letters could be applied over the top.

Combining patterns with lettering

The wonderful pattern effects of the Gospel manuscripts, especially those using initials, can be combined with letters very successfully. Observe the shapes of the initials, as they are often very abstract. One half of an initial could be taken as a shape and transferred to a background. If the background fabric is quite textured, it may be sufficient just to outline the shape using wrapped cords, satin-stitch lines or cable stitch (where a heavier thread is wound on the bobbin and the work is executed upside down). Here, again, the shapes that make up the half-letter could be isolated, cut out from heavily stitched fabric and then applied to a new background using free-machine techniques.

Figure 156 on page 120 shows lines of machine patterns making a frame for the word 'knots'. This word is stitched using the large built-in letters and these are surrounded by lines of whip stitch using free running stitch.

A mixture of machine embroidery and hand stitching could also be used, perhaps using traditional goldwork techniques for the letters. This could be very effective if the letters were cut from gold kid, with a Celtic font for the shapes. The letters may be padded with felt and, when secured, wire threaded with beads could be couched over them. A piece showing this technique can be seen in figure 146 on page 111.

Lettering is an excellent design source and many of the ideas in this chapter could be used as a basis for further experiments and ideas.

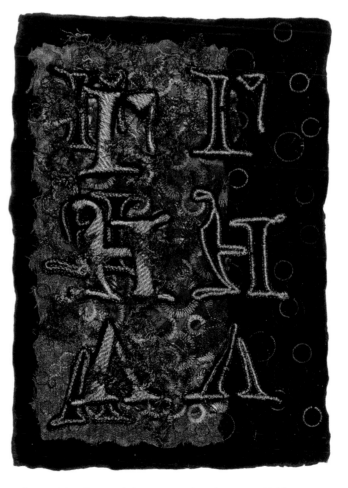

Figure 129 *A flower stitcher was used to decorate a highly patterned fabric, which was applied to black felt. More circles were stitched to blend the two fabrics. Letters were applied on top and wisps of stitching applied to soften the effect.*

The final design

Throughout this book, we have looked at many different methods of translating elements of Celtic design into stitched work. You may already have made some of these into complete pieces. Sometimes a small sample can suggest a way forward to a complete embroidery, and many people are happier with this more intuitive response. Most of us, though, need to have a design to work from. For some, a working drawing will suffice. However, it is easier to have some idea of colour and texture, and working with paints and torn coloured papers can provide a closer approximation. When looking at Celtic sources for your design, consider such artefacts as shrines, jewellery, weapons and, of course, illuminated manuscripts. Look carefully at your chosen source and

do several drawings to get yourself into the feel of it. Make tracings of these drawings and then use the tracings to make further designs, simplifying where necessary and perhaps introducing repeat patterns. You may decide to fit these drawings into a chosen shape, as in the razor outline in figures 130–132. When doing this, look carefully at the negative spaces – the shapes created between the pattern elements. If these are not pleasing, consider adding curved lines or additional patterns to make them so. There is much to be said for a further tracing just of these negative spaces, and this may lead to yet another design (figure 134). Do leave some spaces free, as these give the eye a rest and can emphasize the pattern elements.

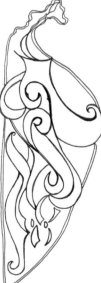

Figure 132 (left) An outline shape was 'borrowed' from an iron razor (also Hungary, third century BC). The designs from figure 131 were adjusted to fit into this shape, and the negative spaces between the patterns were ornamented with additional shapes as necessary.

Figure 130 (left) Tendril patterns were taken from an iron scabbard from Hungary (third century BC).

Figure 131 (above) The pattern was traced and areas were repeated and combined to form alternative designs.

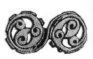

Figure 133 *This design board shows computer designs made from the scanned drawings. Further samples and stitched pieces have also been mounted on the board.*

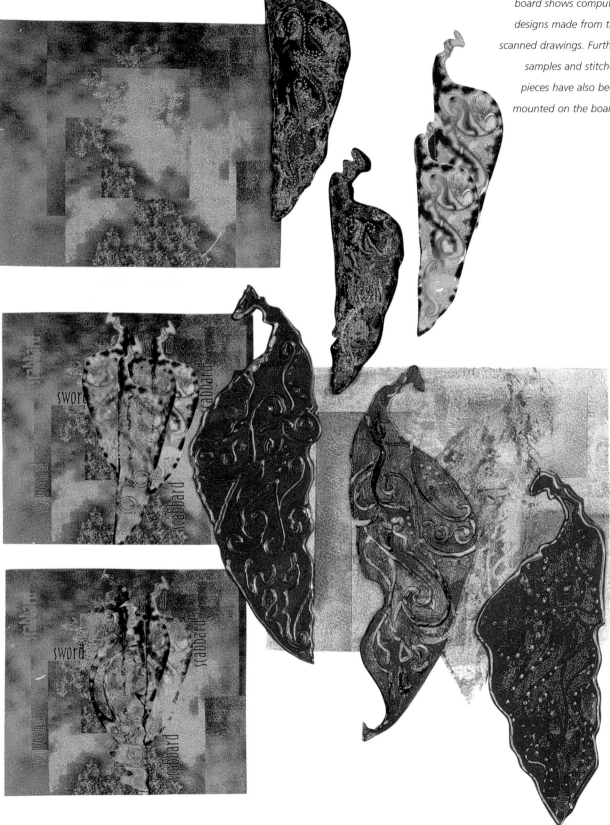

101

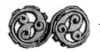

Figure 134 *A grid pattern taken from St Patrick's Bell, which has been fragmented. The negative spaces have then been isolated to form further patterns.*

Figure 135 *Drawing based on the St Patrick's Bell shrine.*

(Janet Edmonds)

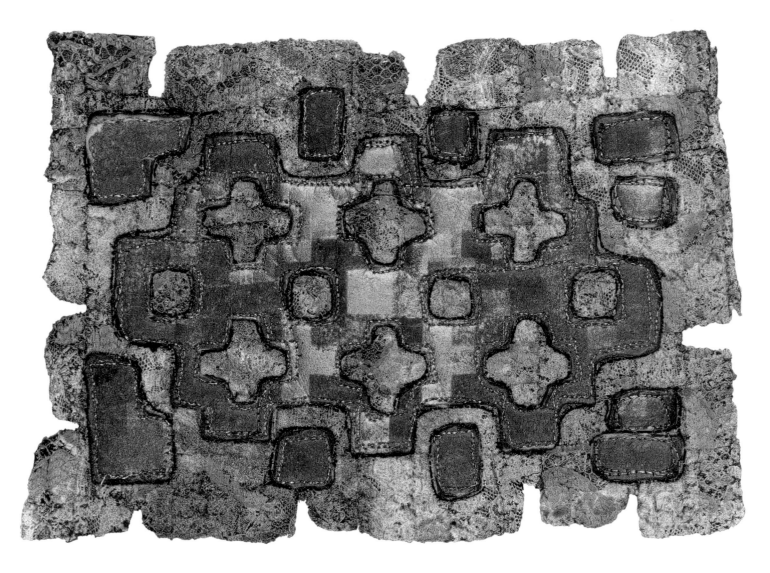

Figure 136 Pattern taken from St. Patrick's Bell. Holes have been burnt in craft Vilene to reveal the underlayers.

Try making a design board combining all your drawings and samples. This can be very pleasing in its own right and, if you exhibit your work, can be displayed with the finished piece. Use a good-quality mountboard or thick card and a spray glue (some are repositionable, which is very useful). Combine the drawings, showing the design development, further design work, any printing or fabric-painting experiments, and the stitch samples made prior to the finished piece. If you are unsure of the final design, living with these samples for a while can clarify thoughts and ideas. Add some notes about the design source, colours and patterns, as these written details often stimulate the mind in other directions. If you are working on a series of embroideries, design boards are useful and can often produce further ideas.

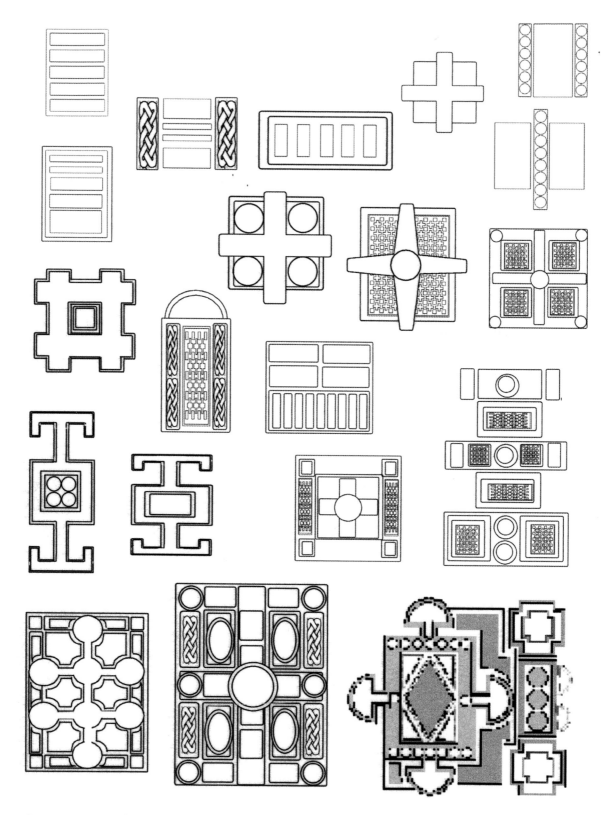

Figure 137 *Drawings from carpet pages and book shrines suggest layouts for panels, hangings and book covers.*

Colour schemes

Don't feel obliged to stick to Celtic colour schemes, which can be limiting. Changing the colour scheme can give a completely different feel to a piece of work. There are many good books on colour and its use. Those intended for painters can be very useful. Do, however, consider the use of contrast. Many otherwise excellent embroideries fail on this. It is too easy to turn work into porridge, so look for contrast – of texture, colour, hard and soft edges, warm and cool, for example – to liven it up.

When deciding on a design for a finished piece, an obvious consideration is the shape of the article and how the Celtic design will fit into the spaces. The designs adapt quite happily to produce panels, cushions, book covers or three-dimensional items. Use all your drawings, sketches and design methods as a base but don't reproduce them too slavishly. It's much better to adapt and extend and so make the piece truly your own.

Think about how to combine the separate elements of the work into a whole. You may, for instance, have decided on a background of spiral printed fabric, borders using knot patterns, and a central motif of larger, more abstracted, knot patterns. It is now time to consider putting them together in a larger work. Decide whether you want symmetry or if you are after an irregular look. Even if your design source is totally symmetrical, it is still possible to take a detail and so lose the regularity. Edges can be hard or soft and should be considered at the beginning of the design rather than as an afterthought. Cut or tear shapes from stiff paper (use some of the papers made in earlier chapters of the book), from block prints or stencils. Obviously if you are going to be using a printed fabric, your papers will be printed with the same design. Experiment with shapes, especially on panels, and use borders, corners and the like to build up and enhance the design. Figure 137 shows some typical layouts drawn from pages of illuminated gospels and book shrines. You could copy the layouts exactly and achieve a good piece of work, but it is much more exciting just to use them as a starting point for your own design.

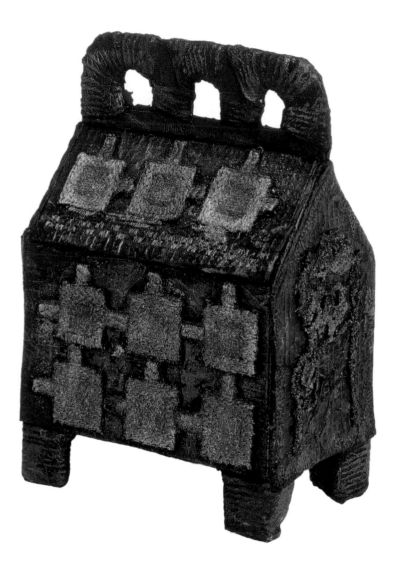

Figure 138 *A casket based on a house shrine, cut from thick card and covered with tissue paper. Patterns are based on those from St Patrick's Bell and used to stitch patches. These are applied to the panels prior to construction. (Clive Grey)*

Isolate areas from the design, as shown in figures 134 and 139 (page 102 and below), and combine elements from several designs or take a detail from one and enlarge it on a photocopier. If it is very blocky, trace over the lines to produce a smooth drawing. Figure 143 offers some further ideas. Borders, corners or similar elements need not be entirely attached to the piece but could be joined by bridges or, at the stitching stage, joined by laying centre and border on water-soluble fabric and stitching between to join them. The cruciform shapes can be very useful and the symmetry can be retained, as in figure 142, or altered by placing the cross to one side of the background square.

Figure 139 *Softer designs taken from figure 137 that suggest embroideries.*

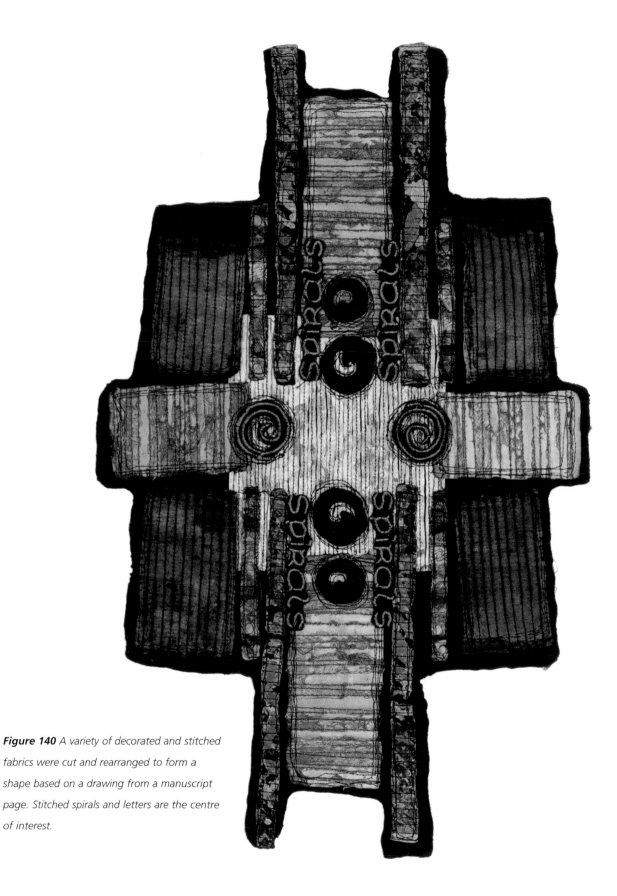

Figure 140 *A variety of decorated and stitched fabrics were cut and rearranged to form a shape based on a drawing from a manuscript page. Stitched spirals and letters are the centre of interest.*

Figure 141 *A panel using a variety of decorated fabrics building up a design based on a drawing from a shrine. The patterns and the knot make a further connection. This was based on the shapes in figure 137.*
(Sandra Coleridge)

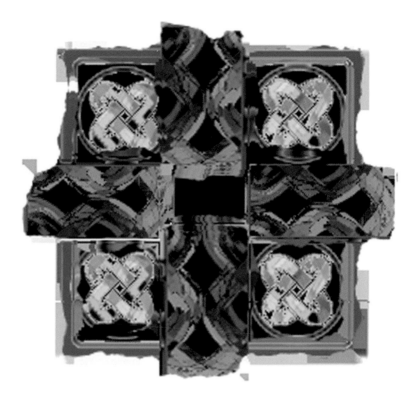

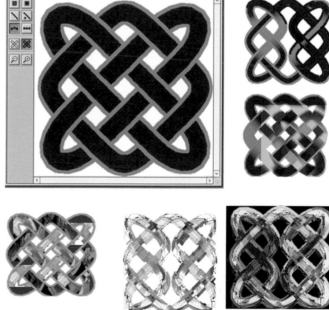

Figure 142 *It was then developed into designs for a border and two small panels. This was also based on shapes from figure 137 on page 104.*

Figure 143 *Designed in a computer program called Celtic Assistant which has been filtered and distressed.*

109

The computer is a wonderful tool for designers and, if your software gives you the opportunity, do make use of the layers facility. You can place different elements of the design on these layers and change (or swap) them easily and quickly. Therefore a border or corner design that has turned out well can be copied and pasted so you can try it with several different backgrounds. This method of working is very like the process of constructing an embroidery. You can make a background, add a layer of stitching and build on this

to add further shapes and motifs. It is also possible to perform special effects on just the background or on just one layer, so this is also useful. Figure 144 shows a design put together in this way. Don't be afraid to mix and match designs on paper with computer designs, either by scanning in some stencilled papers and using them in the computer design, or printing your digital design on handmade paper and using it in a paste-up. It is also possible to print your computer designs onto special transfer paper and then iron them onto fabric.

Figure 144 Final computer design using the drawings in figures 130–133 (pages 100–101) and showing the use of layers.

Figure 145 Drawing from the Lindisfarne Gospels.

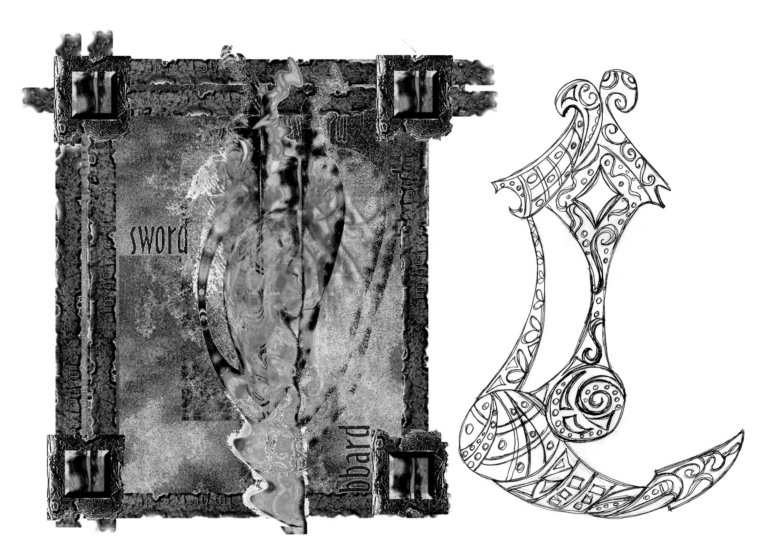

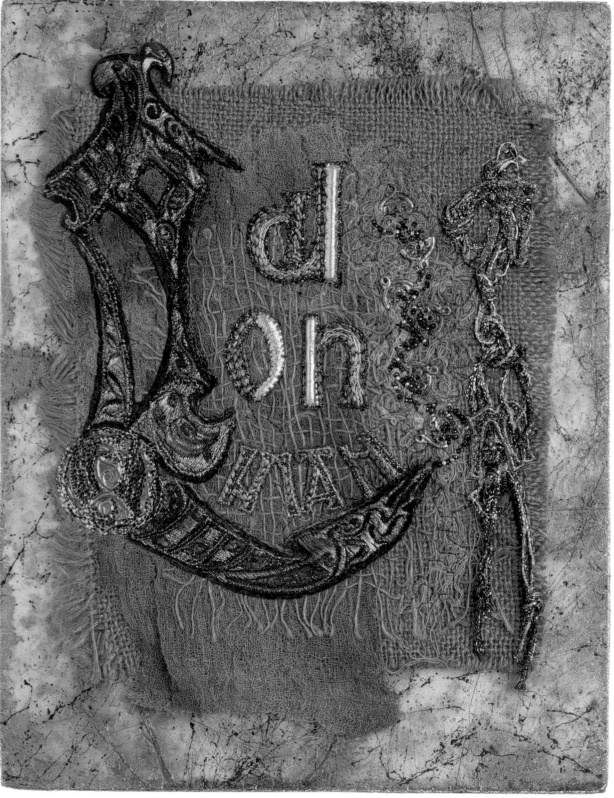

Figure 146 *A panel based on lettering, with goldwork and couching techniques used for the letters.*

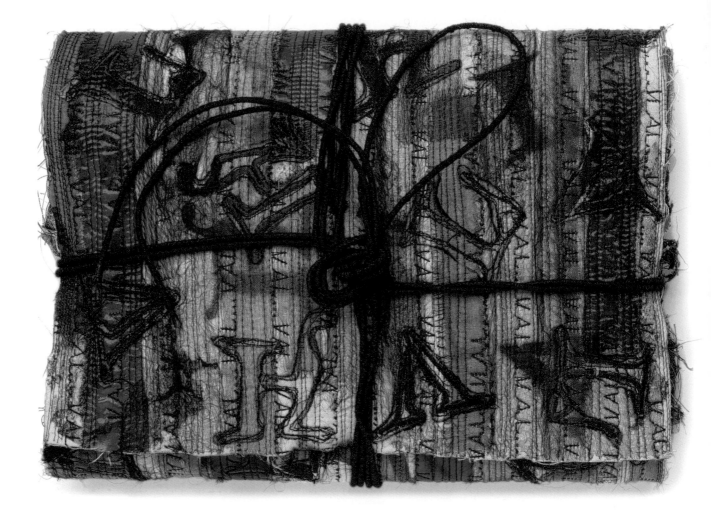

Figure 147 *A book wrap to hold samples of stitched letters. The wrap is covered with strips of transparent fabrics, lines of stitched letters, straight stitch and applied stitched larger letters, secured and then outlined with free running.*

Edges and trimmings

If you are making cushions, book covers or any other piece that will require trimmings, try to make these an integral part of the work. Try making tassel heads from rolled strips of the stitched fabric that was used for the embroidery. Shrink plastic is also very good for making tassels and dangling shapes. Make a tassel head by rolling the coloured plastic with your fingers while it is hot, but do be careful not to burn yourself. This is not suitable for cushions, as it has hard edges. Consider

tabs as the edging for a cushion, with a small related design embroidered on each. Make edgings for panels with strips of cut-out felt, with one of the built-in scroll or cable patterns stitched on it. Planning the edges and finishing touches at an early stage can be very helpful if you want to avoid problems when nearing completion. Consider binding or burning edges, or using handmade braids or stitched slips (see figure 148).

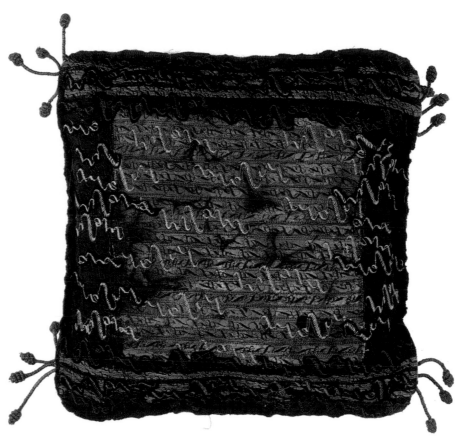

Figure 148 A cushion made from dyed and burnt fabrics and black felt. The pattern was an auto pattern, hugely distorted and enlarged using the sewing-machine facilities and the software. The seams are on the outside and zigzagged cords were stitched into them, knotted at the ends.

Figure 149 A sampler based on the Celtic goose motif (detail). A variety of outline and filled motifs were stitched, having been digitized using sewing-machine software.

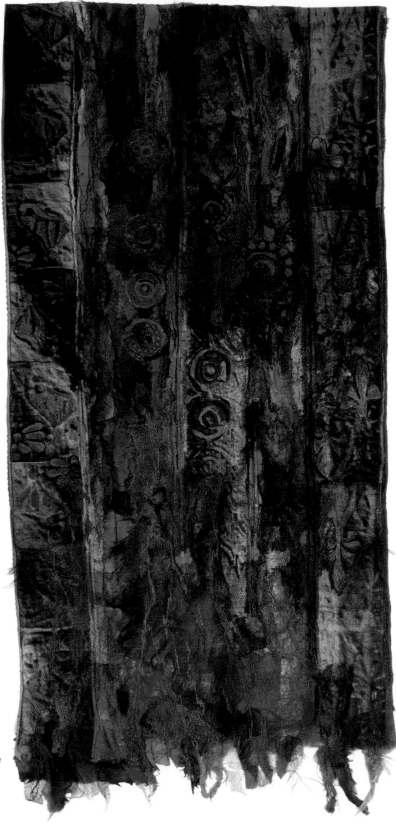

Figure 150 *Panel based on Celtic patterns carved in a stone arch, on painted and stitched fabric with motifs in massed free running.*
(Barbara Haddon)

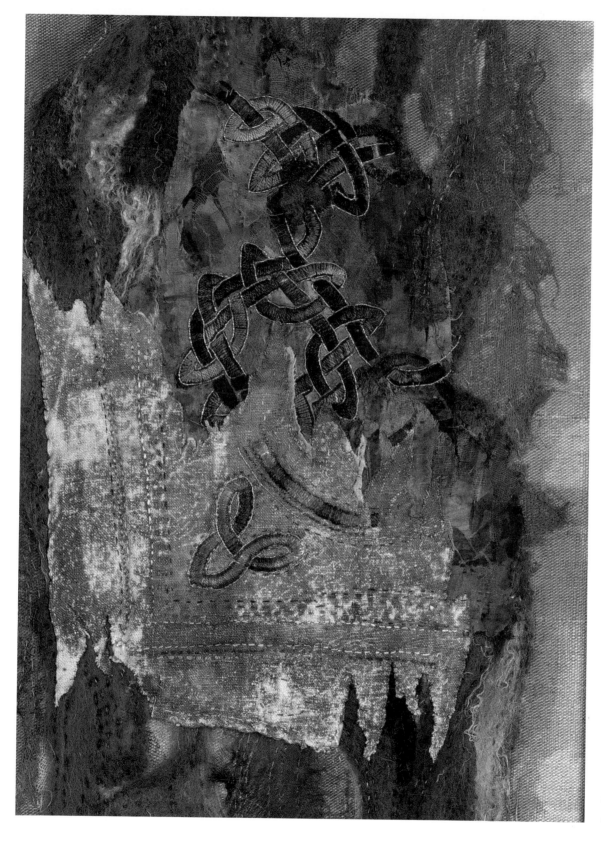

Figure 151 *'Durrow Rediscovered'. Handmade felt combined with hand-dyed silks, which are used for stitched motifs, all based on designs from the Book of Durrow. (Jill Nicholls)*

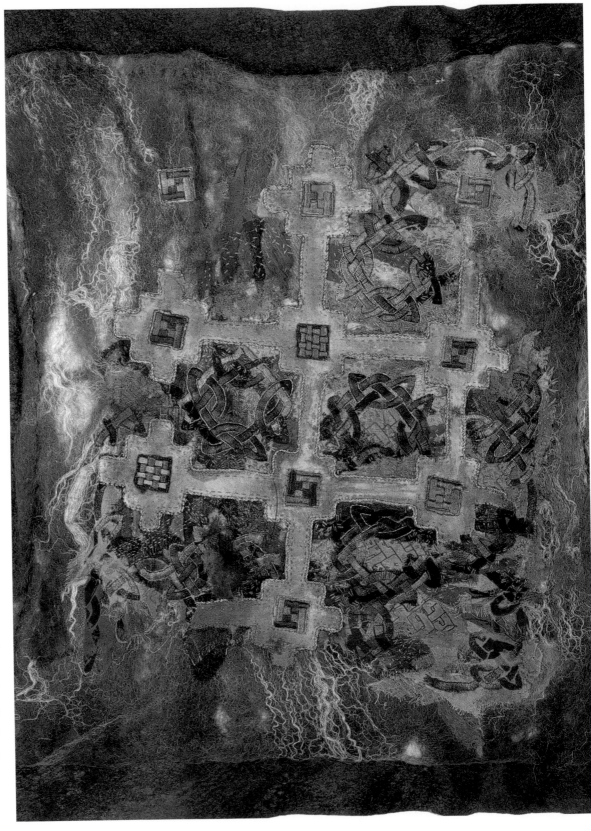

Figure 152 *'Durrow Restored'. A background of dyed commercial felt with applied motifs, from the Book of Durrow. Handmade felt and dyed silks are also used. (Jill Nicholls)*

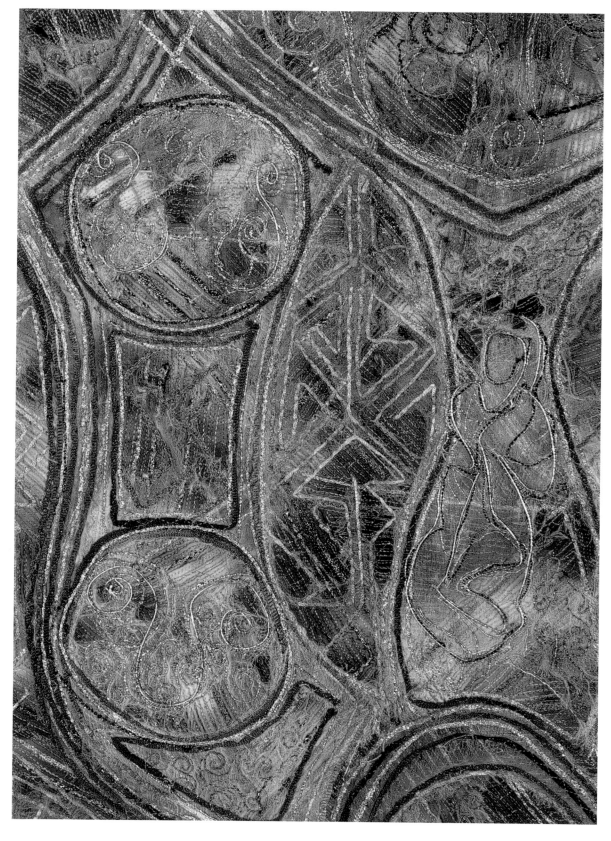

Figure 153 *A wall hanging with a rich surface of irregularly closely tucked fabric and couched lines making the pattern (detail). (Julie Smith)*

117

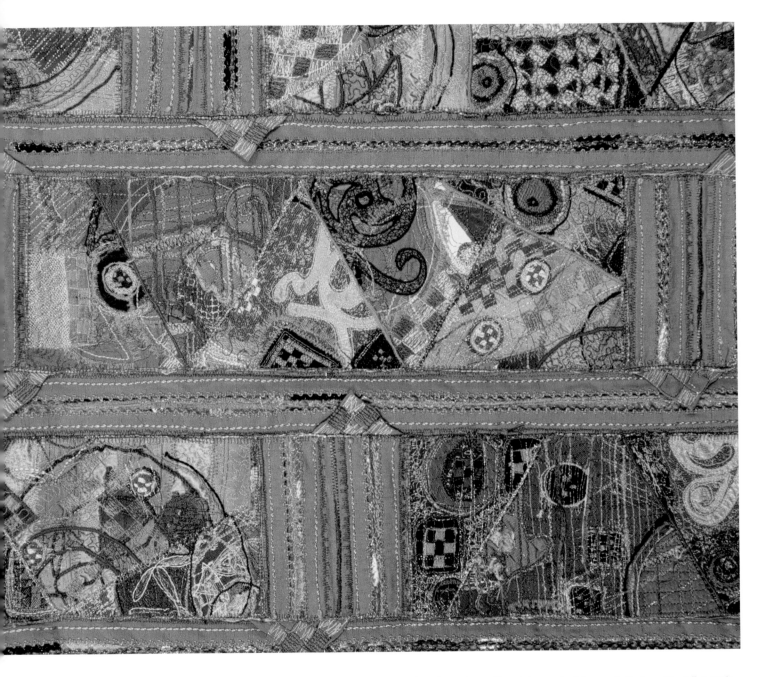

Figure 154 *Celtic Fragments. Richly stitched bands of pattern are pieced together with quiet areas in this panel. (Barbara Howell, now in the collection of Joy Shone)*

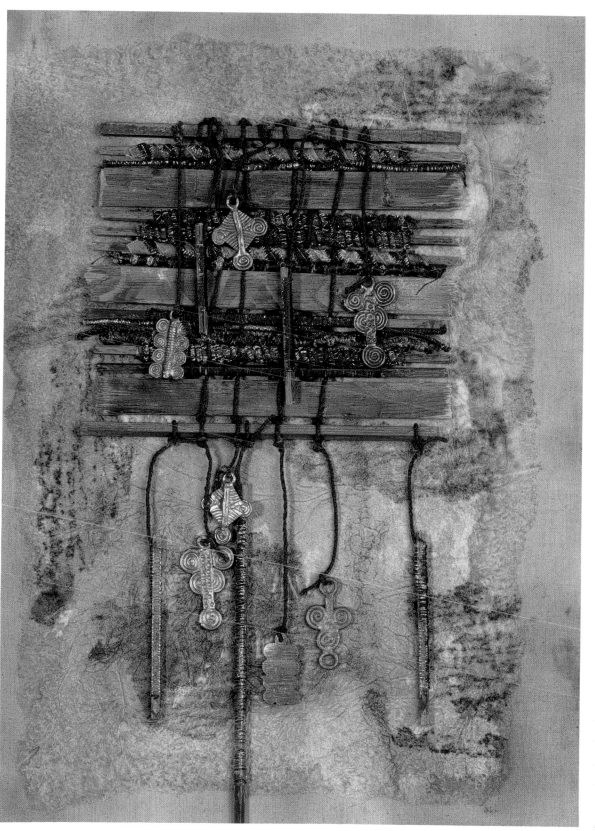

Figure 155 *Painted sticks, wrapped with zigzagged cord, and metallic Celtic motifs hanging freely. (Margaret Curry-Jones)*

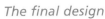

What to do with a failure

Sometimes, despite careful designing and sampling, the piece just doesn't look right. If this happens, first try to understand why this is. Perhaps you have used the wrong colours, or too many different stitches, or there is not enough contrast either in the colour or the texture. If you cannot pinpoint exactly what is unsatisfactory about it, and still feel that it is not worthy of you, try one of the following suggestions to make a new piece. Even if you do not see your current piece of work as a failure, you may find some useful ideas here.

Take the scissors to it

■ Cut the piece into strips and lay them on another fabric, spread apart, and add more stitching to secure them to the background. This background fabric could also have some stitching on it. Perhaps you could also add strips of organza partially covering the stitched strips.

■ Cut your piece into strips and weave them together. You could show the front of the stitching as the horizontal rows, and the back as the vertical ones. Stitch over the top to secure the strips.

■ Cut the stitching into separate shapes. Lay these on water-soluble fabric and join the pieces together with satin-stitched bars, or webs of free running stitch.

■ Cut the stitching into small pieces, then trap these between two layers of transparent fabric. Stitch in the spaces between to make pockets.

■ Pleat a new fabric. Cut the stitching into small shapes and tuck these between the pleats. Stitch to hold them.

■ Cut the stitching into narrow strips and weave the strips through Wiremesh (either painted or stitched), an open-mesh fabric, or through slashes or buttonholes. Weave through a frame and add further stitching.

Figure 156 *Unsatisfactory stitching was cut into strips and laid on net. More left-over pieces of stitched distorted knots, and the word itself, were added to the sides to make borders. Free running secured all the separate pieces.*

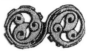

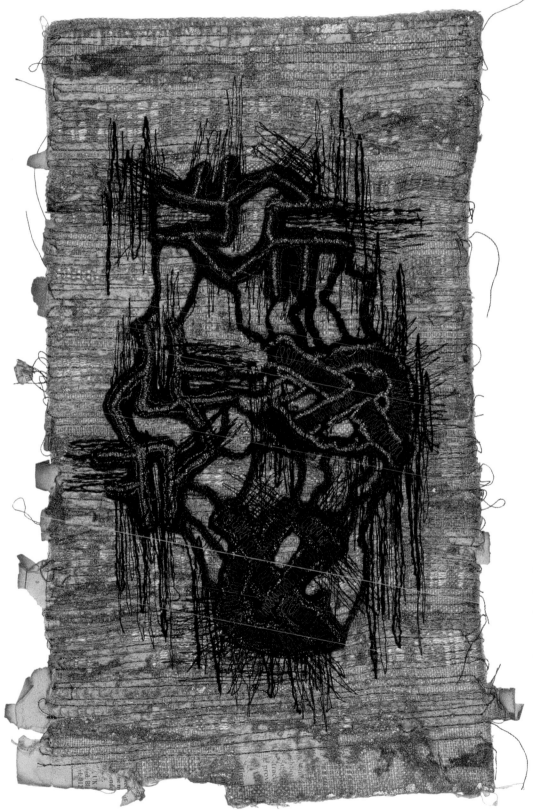

Figure 157

Newspaper was applied to a furnishing fabric, stitched, dyed with coffee, and partially rubbed away. Cut-out stitchery of knot patterns was applied and decorated with hatching using thick and thin thread.

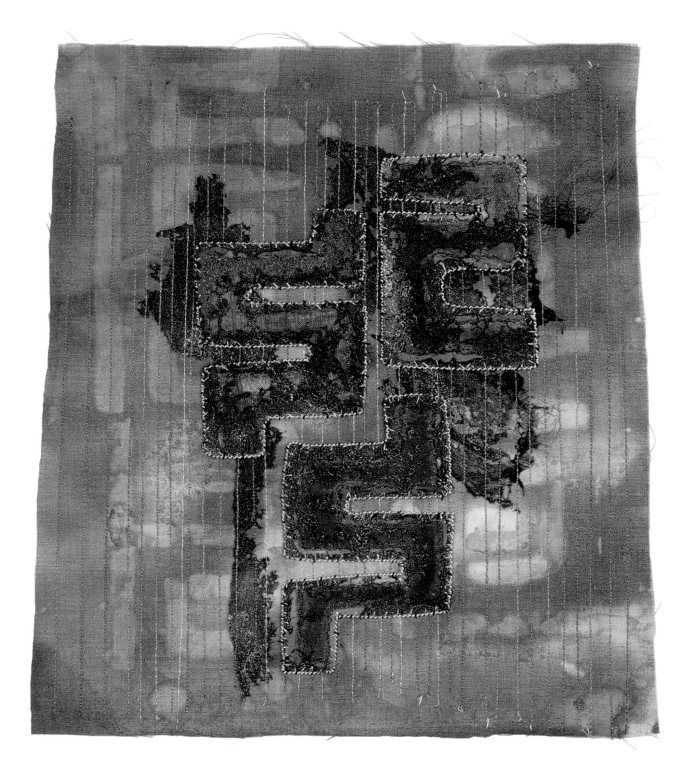

Figure 158 *Wiremesh letters have been consolidated with the background by the use of applied, zapped chiffon and lines of straight stitch.*

Fold, roll or manipulate it

■ Cut the stitching into long triangles or strips, roll these into beads and wrap with a metallic thread.

■ Cut the stitching into squares and fold these into small parcels. Wrap them to hold them, and then connect the parcels with cords or threads to make a string or tassel.

■ If the stitching is soft enough, cut it into circles and gather the edges to pull them up (as for Suffolk puffs). Turn them upside down so that the gathered edges are underneath, then lay them on another fabric or piece of stitching, and machine them down. If you stitch from the edge towards the centre every so often, they will look like bosses or flowers. Try other ways of stitching them.

■ Fold the stitching and secure it with either a running stitch (as for piping) or cover the edge with fairly close zigzag stitching. Make these ridges all over the piece to distort it, either in parallel lines or freely all over the place.

Burn, slit or slash it

■ Cut slits into the stitched piece and burn them to make them bigger.

■ Either pull up another fabric into the slits – as the Elizabethans did on their marvellous costumes – or thread something else through them.

■ Work automatic buttonholes all over the piece, then pull the edges of two different buttonholes together and hold them in place by working a satin-stitch block over them (by hand) as if you were smocking.

■ Cut irregularly shaped pieces out of the stitching and lay it on a background fabric. Place the cut-out shapes back on top and work more stitching to blend them in. You could pad them before they are stitched.

Cover it

■ Cover the piece with organza, do more stitching, then cut through or heat-'zap' it.

■ Cover the piece with a painted and stencilled nappy (diaper) liner, stitch around the stencil and 'zap' it.

■ Paint it with white distemper, leaving pale colour showing through. Then stitch again.

Conclusion

There is an enormous amount of design potential in Celtic artefacts and we do hope that we have inspired you to start exploring them, using a wide variety of media and techniques. You may find, as we do, that certain motifs or borders become firm favourites (you will have noted several that pop up throughout the book). These are very useful if you are producing a series of work for an exhibition, as they will provide links to pull everything together. It is also our hope that you will find the ideas for design and embroidery useful for other sources. The pattern of observing, drawing and expanding the drawings using prints, stencils and the like – determining a shape and design for the final piece and finally stitching it – is one that will work for almost all inspirational material. Most important of all, enjoy the process.

Resources

Books

These are some of the many books about Celtic art that we have found useful.

The Art of the Celts, David Sandison, Hamlyn

The Art of the Manx Crosses, AM Cubbon, Manx
 National Heritage

The Book of Kells, Peter Brown,
 Thames & Hudson

Celtic and Anglo-Saxon Painting,
 Carl Nordenfalk, Chatto & Windus

Celtic Art, George Bain, Constable

Celtic Art, Ruth & Vincent Megaw,
 Thames & Hudson

Celtic Art and Design, Iain Zaczek,
 Studio Editions

Celtic Borders, Aidan Meehan,
 Thames & Hudson

Celtic Design, Iain Zaczek, Studio Editions

Celtic Design: A Beginner's Manual, Aidan Meehan,
 Thames & Hudson

Celtic Initials & Alphabets, Courtney Davis, Blandford

Celtic Knotwork, Iain Bain, Constable

Celtic Knotwork Designs, Sheila Sturrock,
 Guild of Master Craftsmen

Celtic Mysteries, John Sharkey,
 Thames & Hudson

Celtic Spirals, Sheila Sturrock, Guild of Master
 Craftsmen

Celtic Treasury, Catriona Luke,
 Michael O'Mara Books

The Dragon and the Griffin, Aidan Meehan,
 Thames & Hudson

Early Celtic Designs, Ian Stead and Karen Hughes,
 British Museum Press

8,000 Years of Ornament, Eva Wilson,
 British Museum Press

Exploring the World of the Celts, Simon James,
 Thames & Hudson

The Golden Age of Irish Art, Peter Harbison,
 Thames & Hudson

How to Draw Celtic Key Patterns, Andy Sloss,
 Blandford

How to Draw Celtic Knotwork, Andy Sloss,
 Blandford

Illuminated Letters, Aidan Meehan,
 Thames & Hudson

Irish Shrines & Reliquaries, Raghnall O'Flionn,
 National Museum of Ireland

The Lewis Chessmen, Neil Stratford,
 British Museum Press

The Lindisfarne Gospels, Janet Backhouse, Phaidon

Spiral Patterns, Aidan Meehan,
 Thames & Hudson

The Sutton Hoo Ship Burial, Angela Care, Evans

Internet sites

The Internet can be an extremely valuable source of Celtic material. Whether you want to download copyright-free images, or you are just looking for a bit of inspiration, there is sure to be a site to suit your needs. All these sites have been checked, but if you have trouble with any of them just do a general search, typing in the subject you wish to look for. Try 'Celtic', 'Celtic Art', 'Celtic Design' or 'Celtic clothing' and choose from an enormous number of sites.

Celtic art

There are so many Internet sites on Celtic art that it is difficult to choose one. Try the following:
www.aon-celtic.com
www.celtic-art.net
www.celtic-art.com
This is the web page of Courtney Davis, the Celtic Illustrator. If you have problems with accessing the site, search for 'Courtney Davis'.

Celtic designs

Try these sites for free designs, patterns, backgrounds and fonts to download.
www.celtic-clipart.co.uk
www.ireland-information.com/freecelticfonts.htm
www.geocities.com/SoHo/5872/graphics.html

Computer software

There are several CD-ROMs on the market containing Celtic clipart and fonts:

Celtic Alphabets CD-ROM and Book
Celtic Designs CD-ROM and Book

Copyright-free fonts and designs. Available from the Dover Bookshop, 18 Earlham Street, London WC2H 9LG, tel: 020 7836 2111.
www.thedoverbookshop.com
store.doverpublications.com

ProScribe Clipart and Celtic fonts

This CD-ROM contains Celtic motifs, borders, letters and carpet pages which are copyright-free. There are also five fonts based on the Book of Kells and the Lindisfarne Gospels. There are also knotwork fonts designed for creating Celtic knotwork – each letter on the keyboard is a different segment of a knot. Available from Creative Technology (MicroDesign) Ltd, Park House, 10 Park Street, Uttoxeter, Staffordshire ST14 7AG, UK. Tel: 01889 567 160.
www.proscribe.co.uk

The Book of Kells

The entire Book of Kells is available on a CD-ROM from the Trinity College Library Shop, Dublin. Library Shop, Trinity College, College Street, Dublin 2, Ireland. Tel: 00 353 1608 1171
www.tcd.ie/library/online.htm

Kells font

Two fonts based on the Book of Kells, plus some small Celtic motifs, are available from the P22 Type Foundry, PO Box 770, Buffalo, NY 14213, USA.
www.p22.com

Suppliers

Sewing machines

Bernina, Bogod Machine Co Ltd, 50–52 Great Sutton Street, London EC1V 0DJ

Brother, Shepley Street, Audenshaw, Manchester M34 5JD

Husqvarna/Pfaff, Husqvarna Viking House, Cheddar Business Park, Wedmore Road, Cheddar, Somerset BS27 3EB.

Janome Centre, Southside, Bredbury, Stockport, Cheshire SK6 2SP.

The following suppliers do mail order and will send you a catalogue:

Equipment and materials

Art Van Go, 16 Hollybush Lane, Datchworth, Knebworth, Herts SG3 6RE
(heat guns, respirators, Xpandaprint, Markal [Shiva] oilsticks, masks, metal mesh, webbing spray, PearlEx, Wireform).

Inca Studio, 10 Duke Street, Princes Risborough, Bucks HP27 0AT
(Kunin felt, water-soluble fabric and paper, 505 spray).

Oliver Twists, 22 Phoenix Road, Crowther, Washington, Tyne & Wear NE38 0AD
(metal shim, machine embroidery threads).

Rainbow Silks, 6 Wheelers Yard, High Street, Great Missenden, Bucks HP16 0AL
(fabrics, paints, webbing, 505 spray).

Strata, Oronsay, Misbourne Avenue, Chalfont St Peter, Bucks SL9 0PF
(Xpandaprint, chiffons).

Winifred Cottage, 17 Elms Road, Fleet, Hants GU13 9EG
(variegated threads, water-soluble paper).

Fabrics
Whaleys (Bradford) Ltd, Harris Court Road, Great Horton, Bradford, West Yorks BD7 4EQ.

Threads
Silken Strands, 20 Y Rhos, Bangor LL57 2LT
(a vast range of machine embroidery threads).

Flower stitcher
Franklyn's of Colchester, tel. 01206 563 955 or 574 758.

USA

Most materials used in the book are available from art shops, but specifically:

Dick Blick Art Materials (Mail Order),
1-800-447-8192
(general art materials, including Shiva [Markal] oilsticks)

Gerber EZ-Liner Diaper Liners, 1-800-4-GERBER.

Nancy's Notions, *www.nancysnotions.com*
(flower stitcher).

Kunin Felt
380 Lafayette Road
Hampton
NH 03842
USA
1-800-292-7900
('zappable' felt).

Index